SCARBOROUGH & WHITBY RAILWAY

THROUGH TIME

Robin Lidster

AMBERLEY PUBLISHING

In Memory of
Ken Hoole
1916 – 1988

Railway historian and author whose generosity and encouragement
stimulated my interest in local railway history.

Front Cover photographs
Cloughton Station: a delightful destination – then and now
In the early morning sunshine the friendly station cat prowls the platform,
where trains once arrived and departed, to investigate whether the
intruding photographer is a likely source of an early breakfast!

In the same series by Robin Lidster:
Robin Hood's Bay & Fylingthorpe Through Time

First published 2010

Amberley Publishing Plc
Cirencester Road, Chalford,
Stroud, Gloucestershire, GL6 8PE

www.amberley-books.com

Copyright © Robin Lidster, 2010

The right of Robin Lidster to be identified as the
Author of this work has been asserted in accordance
with the Copyrights, Designs and Patents Act 1988.

ISBN 978 1 84868 668 7

British Library Cataloguing in Publication Data.
A catalogue record for this book is available from
the British Library.

Typeset in 9.5pt on 12pt Celeste.
Typesetting by Amberley Publishing.
Printed in the UK.

Introduction

The Scarborough & Whitby Railway (referred to in this book as S&WR) was opened on 16 July 1885. It had taken thirteen years to build although for a few years, in the 1870s, it remained dormant as insufficient capital could be raised to complete it and the original engineer and contractor pulled out. A fresh start was made by the new contractors, John Waddell & Son of Edinburgh, in 1881, under the new engineers, Sir Charles Fox & Sons of Westminster.

From the opening the line was worked by the North Eastern Railway Company (NERCo) that provided the engines, rolling stock and staff and shared the gross profit equally with the S&WRCo. The line had cost £27,000 a mile to build and, after working the line at a loss for some years, the NERCo bought out the S&WRCo in 1898.

The railway ran through a rich and varied countryside as described in the S&WRCo guide of 1897 –

The line runs though pleasant undulating pasture lands at either end, winds in and out amongst gorse and heather-clad hills, dips into wooded dales, skirts the edge of a wild moor, climbs the highest cliff on the Yorkshire coast, runs round one of the bonniest bays in the Kingdom, and over a portion of its course is perched on the brow of a cliff against which the waves ceaselessly break. In the short 20 miles it covers there is endless variety of wild and picturesque scenery.

The line proved very popular with holidaymakers and visitors for the eighty years that it was open. The guide referred to above (see page 79) included many suggestions for day's outings from most of the stations with details of walks to many of the local beauty spots and points of interest.

The line officially closed on 8 March 1965 (the last passenger train ran on 6 March) bringing to an end what could arguably be said to be one of the most scenic railway journeys in the country. The track between Scalby and Hawsker was lifted three years later and the track from Hawsker to Whitby in 1974. In 1975 Scarborough Borough Council bought the track-bed and most of the station buildings between Scalby and Hawsker for £29,500. The station buildings were sold off but the

track-bed was retained and opened as a public footpath (referred to as the trailway in this book). It has become a very popular walking, cycling and horse-riding route with local people and holidaymakers.

It is the aim of this book to illustrate not only changes that have taken place during the course of the railway's history, but also some of the changes that have taken place subsequent to its closure. The eight stations on the line all had their own individual characters and varied considerably in their appearance and the accommodation they offered for passenger and goods traffic. The smallest station was Hayburn Wyke that was little more than a staffed halt serving the needs of day-trippers. The largest station was Robin Hood's Bay with its imposing stone-built station master's house and extensive facilities.

The fate of the station buildings has also been very different. Scalby station was completely demolished in 1974 and at Hayburn Wyke and Ravenscar stations only the platforms have survived. Cloughton station has become a popular place to visit with its holiday accommodation, camping coach and tea room whilst at Robin Hood's Bay all the buildings have taken on a variety of different uses.

The S&WR still survives, as a valuable recreational amenity, and continually evolves and no doubt will continue to do so into the future and I hope that this book will provide a glimpse into the past for those who enjoy walking along this historic and picturesque trailway.

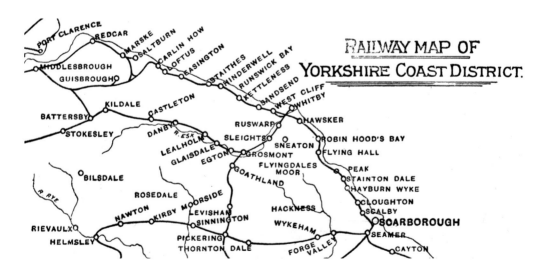

Map of lines
This map, from a North Eastern Railway guide book of 1896, shows the Scarborough & Whitby Railway and nearby lines. Note that Peak station was renamed Ravenscar in 1897; and Fyling Hall has been misspelled.

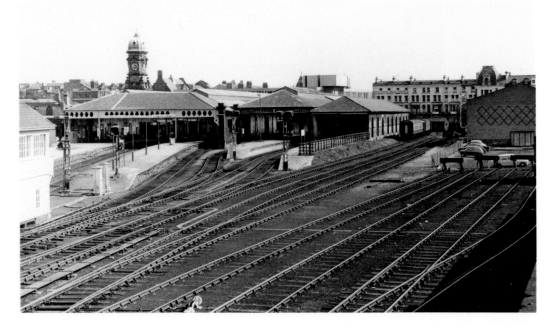

Scarborough Station from Westwood

Scarborough Station once extended right across to Westwood and the area on the extreme right of the earlier photograph was once a busy coal yard. Trains for Whitby originally used the short platforms, 7, 8 and 9 that had been built under the roof of the former goods shed, near the centre of the photograph. All the sidings on the right have been removed and parking for cars and coaches created in this area.

Inset: a Scarborough Central station enamel totem sign.

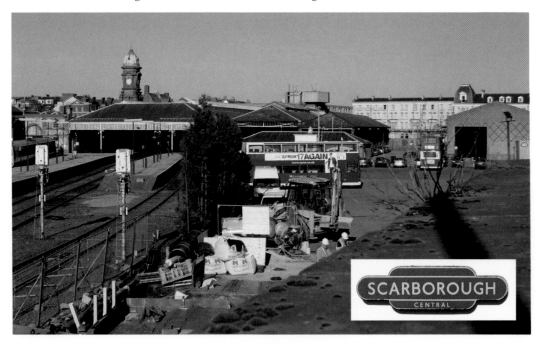

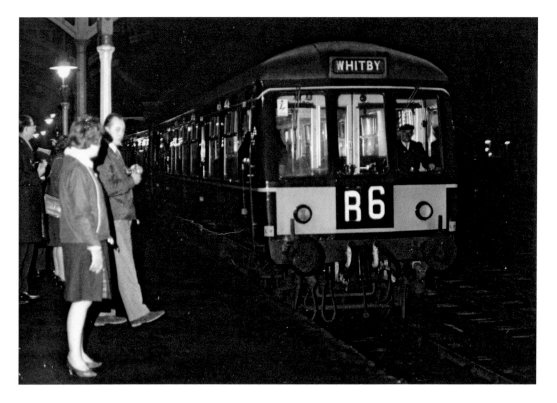

The Last Train to Whitby

The last passenger train on the S&WR, the 7.55pm to Whitby on 6 March 1965, is seen here in Scarborough, shortly before departure, watched by a small group of well-wishers. The four tickets were all issued for travel along the line on the same day although many more were bought that day, as historic souvenirs, than were actually used. The S&WR was officially closed, two days later, on 8 March 1965, bringing to an end eighty years of train travel along this coast.

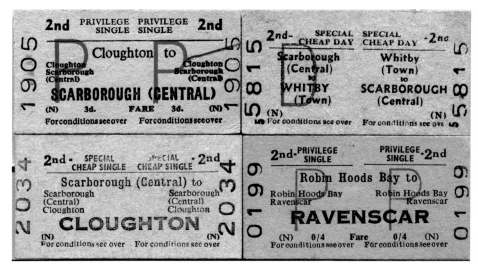

Falsgrave Signal Box and gantry

A passenger train from Middlesbrough, having emerged from Falsgrave tunnel, passes the back of platform 1A where a crowd of passengers wait to board it for the return journey in August 1954. Platform 1A was built, at the end of platform 1, in front of Falsgrave signal box in 1933. It eased the working of S&WR trains in the busy summer months. The tunnel is now bricked up and can be seen just to the left of the signal box in the recent photograph.

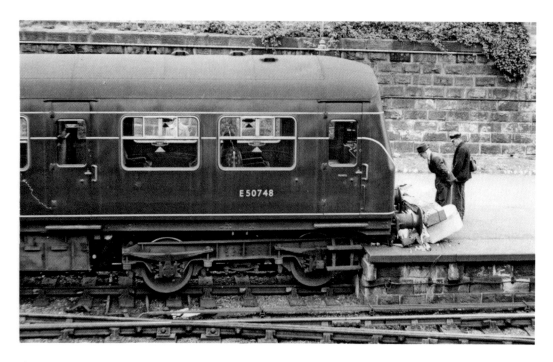

The train now resting on Platform 1A...

The shortness of platform 1A was an unexpected hazard to drivers not familiar with the layout of Scarborough station and expecting to drive right into the station a further 200 yards ahead. This Diesel Multiple Unit ended up resting on the platform in June 1960. The track was lifted a few years after the S&WR closed and, more recently, the tunnel was partly filled in enabling new buildings to be constructed in Belgrave Crescent and on Westover Road near the site of the tunnel.

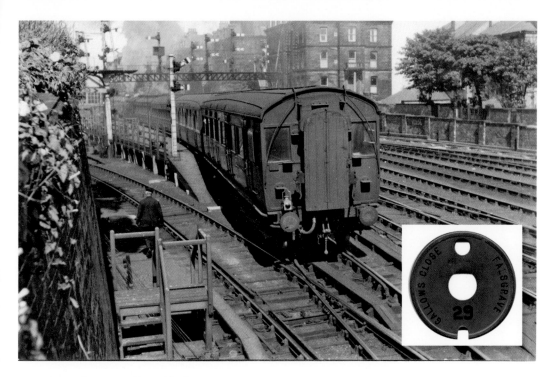

Reversing away from Platform 1A

The S&WR was a single track line with passing loops at Cloughton, Stainton Dale, Ravenscar (from 1908), and Robin Hood's Bay. The single line system involved the use of tablets that had the names of the signal boxes or stations on them. The train is reversing out of 1A platform and will then run forward to the tunnel, picking up the tablet for Falsgrave – Gallows Close, from the signalman at Falsgrave box. Steam locomotives can still be seen at Scarborough – 'Duchess of Sutherland' visited the town on 10 April 2010.

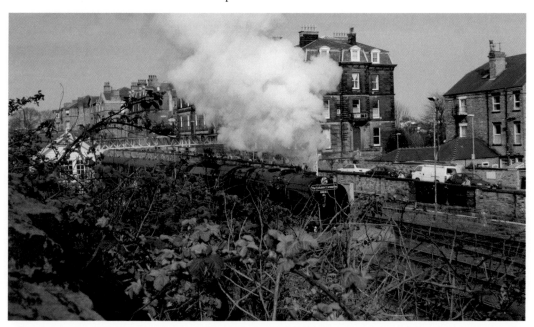

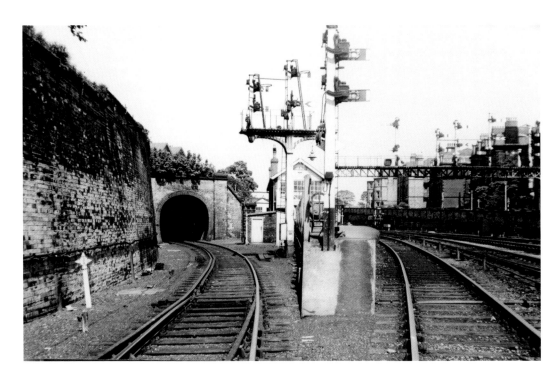

Signalling the changes at Falsgrave

Taken from the end of platform 1A this photograph shows the platform line on the right and the line through the tunnel on the left. The array of signals in the foreground became redundant when Gallows Close goods yard closed in the 1980s. In recent years the track has been lifted, the tunnel mouth bricked up, and work is currently on hand to make Falsgrave signal box, and the signal gantry, redundant by the installation of a new electronic signalling system at the station.

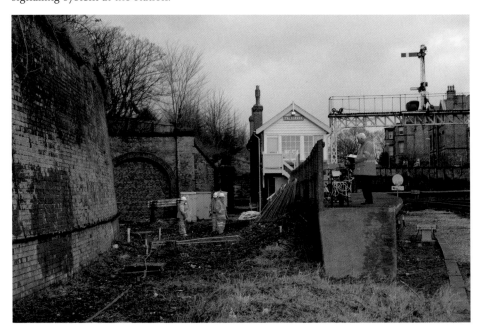

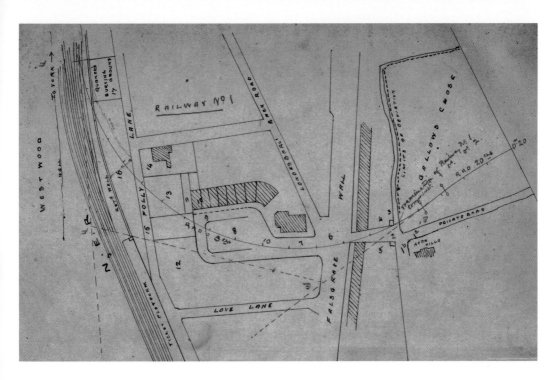

Plans for a tunnel at Falsgrave

These two illustrations are from the engineer's notebook that dates from the early 1880s. It shows how the line was planned to run through a tunnel under Falsgrave Road avoiding the houses in Belgrave Crescent on the way by the use of a very tight curve. The tunnel was built by the 'cut and cover' method whereby a cutting was made; the brickwork of the tunnel built and then covered over. The total cost of the tunnel, which was 260 yards long, was about £10,000.

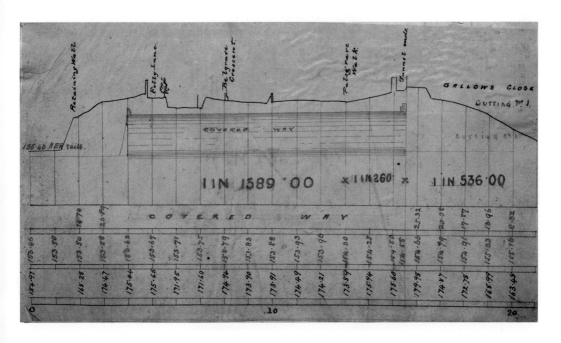

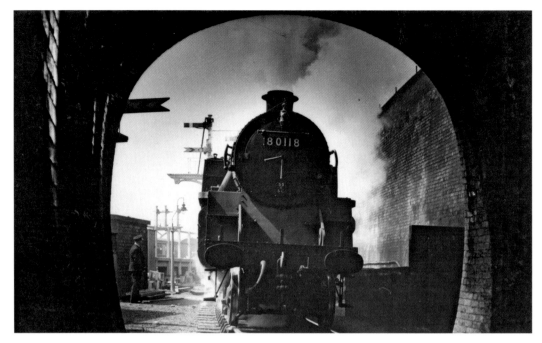

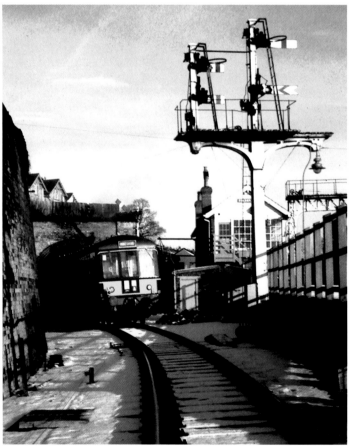

Tunnel entrancement! This atmospheric shot of a locomotive standing at the entrance to the tunnel was taken as it waited for the signal to proceed through to Gallows Close. The brickwork for the tunnel was commenced in August 1882 and completed in June 1883. The tight curve of the tunnel restricted the use of some of the larger engines and coaching stock. Left, a DMU glides into the tunnel on 6 March 1965, the last day of passenger traffic on the line.

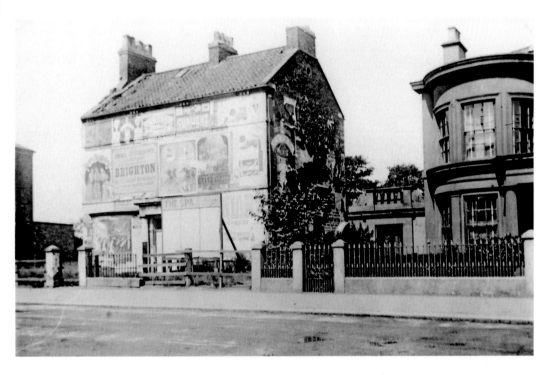

West Parade Road: making an entrance
This derelict house, marked on the plan on page 11 as Avon Villa, was on land owned by the S&WRCo that had been bought in order to build the tunnel. As the house was close to the tunnel it was not considered safe to be habitable and was used as an advertising hoarding until it was demolished in the early 1890s. When the supermarket was built on the Gallows Close site the land on which the old house stood was taken to enlarge the access road.

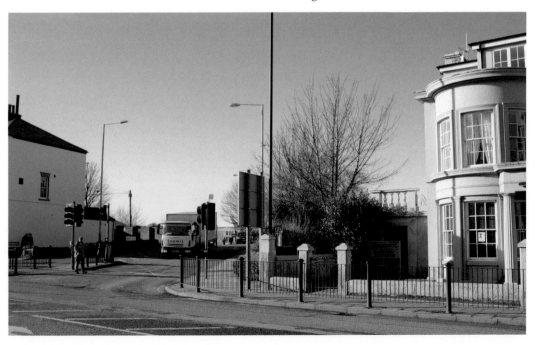

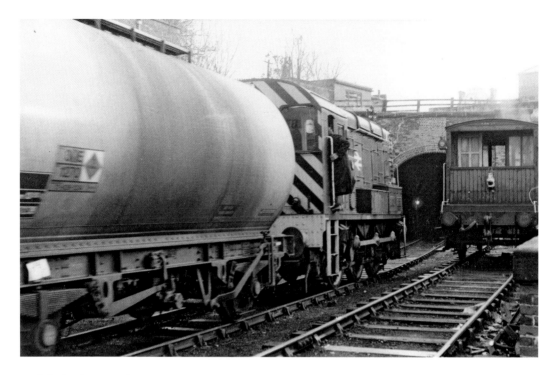

A Light in the Tunnel

Prior to the final closing of Gallows Close goods yard for rail traffic in the 1980s coal and oil were dealt with here and the top photograph shows the diesel shunter about to take empty oil tank wagons through the tunnel. Below, a view on the same day shows the interior of the tunnel undergoing its annual inspection for damage and deterioration. Great excitement had been caused when the shunter and its wagons suddenly appeared in the tunnel whilst the inspection team were at work!

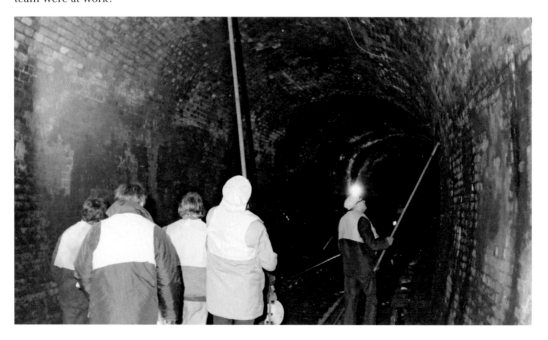

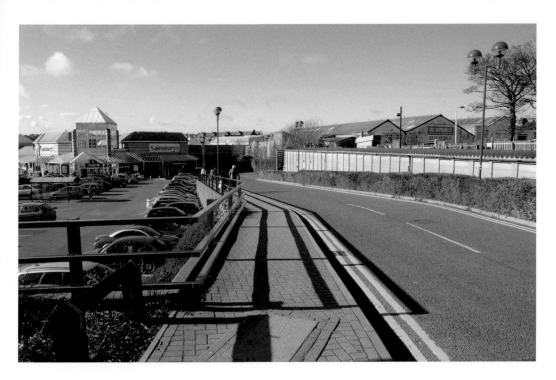

Transformation of Gallows Close

The view from the top of the tunnel has changed out of all recognition and it is almost impossible to find any trace as the tunnel mouth is buried under the top of the road on the right. Where there was once a railway heading north from the tunnel there is now a road sloping down to Sainsbury's supermarket. The only feature that has not changed is the prefabricated concrete building on the right that has been used as a rifle range for many years.

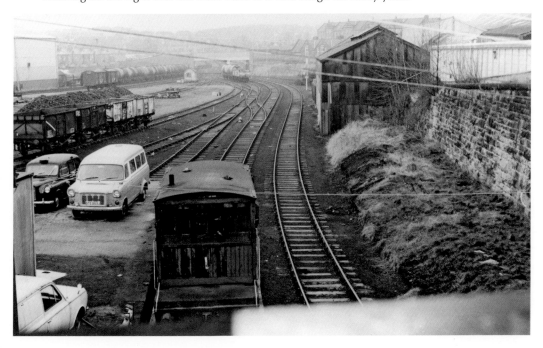

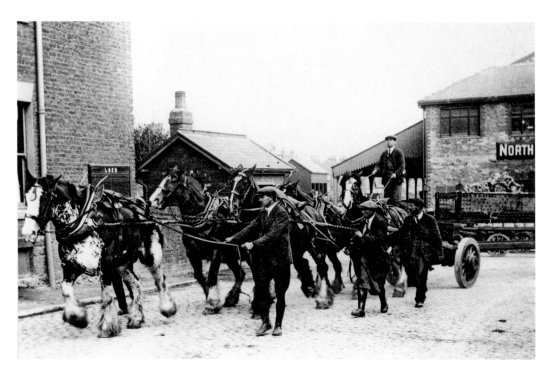

Gallows Close Goods Yard: making an entrance

The entrance to the goods yard, from Falsgrave Road, was made in 1899 in conjunction with the development of the yard between 1899 and 1902. For many years the yard dealt with most of the goods traffic in and out of Scarborough. The road access to the site has been closed, being replaced by the one on page 13, and this one is now a pedestrian route to Sainsbury's supermarket. Gallows Close was originally planned as the location of the terminal station of the S&WR.

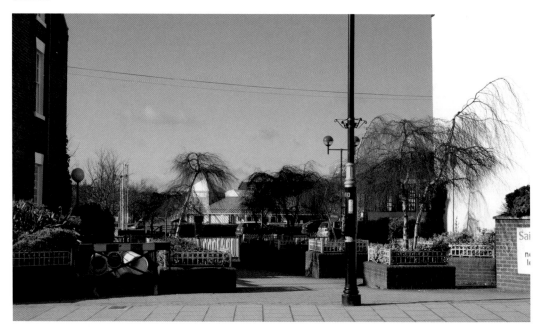

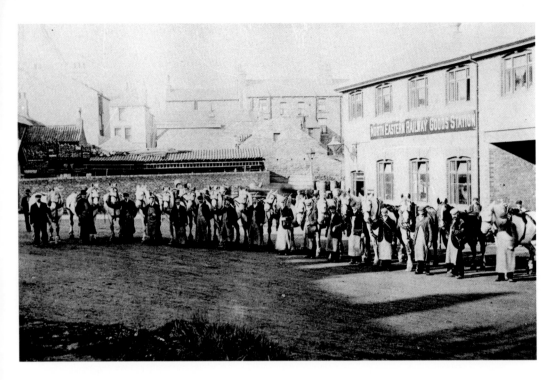

Goods Station to Fuel Station

Construction of the North Eastern Railway Goods Station commenced in 1901 and was completed the following year. The offices occupied the whole front of the building with a central access for road vehicles (on the right). The building measured 112 feet wide by 250 feet long and there were two long platforms inside, one for incoming and one for outgoing goods. The present day fuel station run by Sainsbury's is approximately in the position that the original goods station offices occupied.

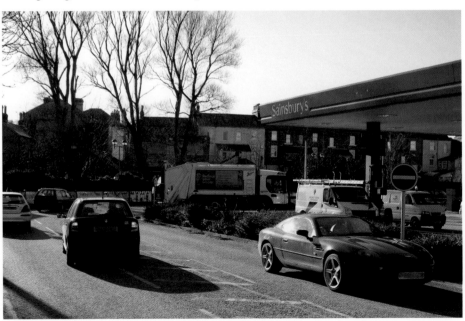

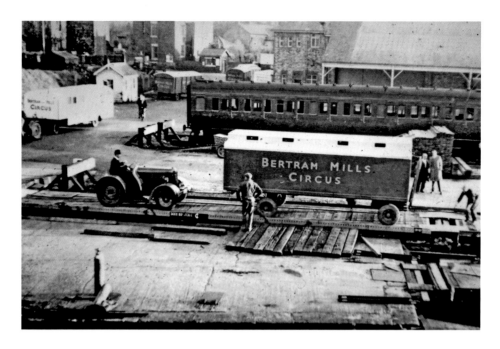

Big Top and Over the Top

Bertram Mills Circus was a regular visitor to Scarborough and often used the facilities at Gallows Close. The carriage in the background provided accommodation for the circus staff. The siding where the coach stands, and the one immediately in front of it, were considerably shortened soon after, as seen in the lower photograph, but the driver who shunted the open wagons was unaware of this and two wagons have gone over the top of the sleeper end stop and smashed into a pick-up truck.

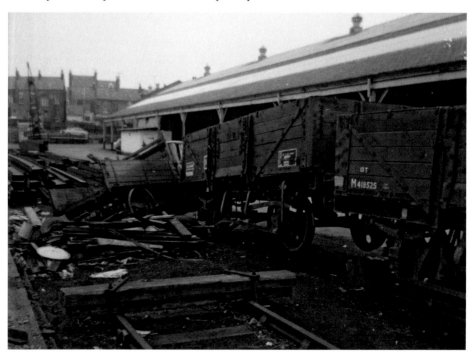

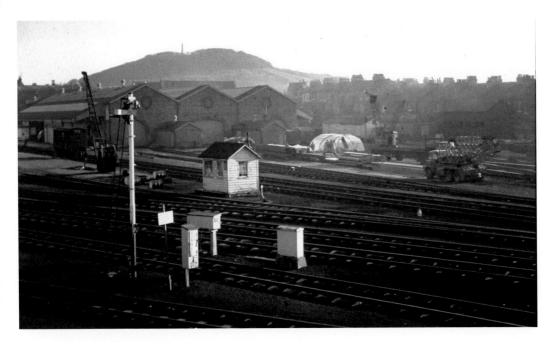

Sunset at Gallows Close

The sun sets on the extensive sidings of the goods yard shortly before most of the tracks were taken up in 1981. Oliver's Mount appears to hover above the three-span roof of the goods warehouse that was taken over by National Carriers, the road haulage firm, until the site was cleared for the erection of a supermarket. Both photographs were taken from Wykeham Street bridge, as were the photographs on the next two pages, showing the changes that have taken place on this site.

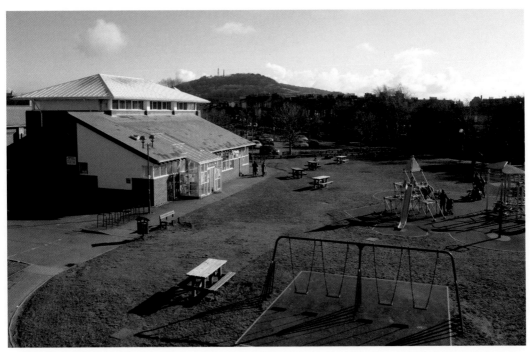

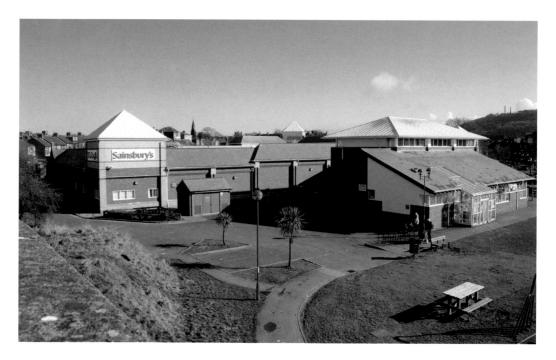

Gallows Close Panorama

Sainsbury's supermarket dominates the present day view from Wykeham Street Bridge. On the right Gallows Close Community Centre and its playground provide a welcome facility for local people. The lower picture, and the one on the opposite page, provides a panorama of Gallows Close goods yard after the first stage of reduction in the late 1970s. On the left the coal yard had been updated in 1961 by the building of hoppers and a rotating conveyor belt system.

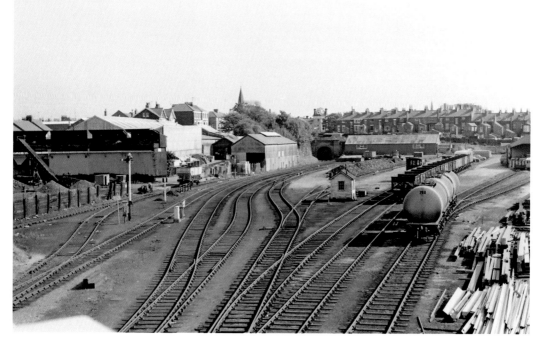

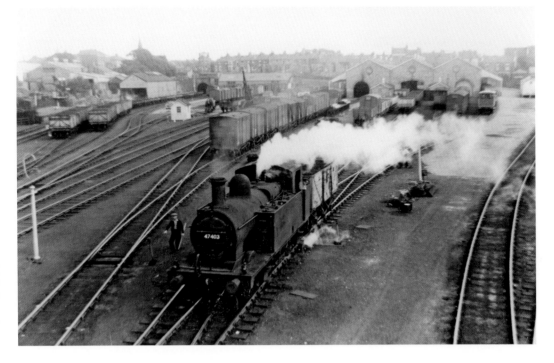

The Rise and Fall of Gallows Close

Some idea of the amount of traffic in the goods yard can be gauged from this picture, taken in January 1960, when all the sidings were still in use and the number of different open wagons and vans indicate the variety of traffic dealt with here. The lower photograph, forming a panoramic view with the one on the opposite page, shows how, by about 1980, all the sidings leading into the goods warehouse had been lifted and the land on the right was being levelled for redevelopment.

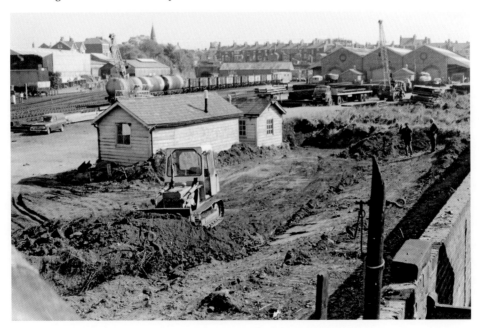

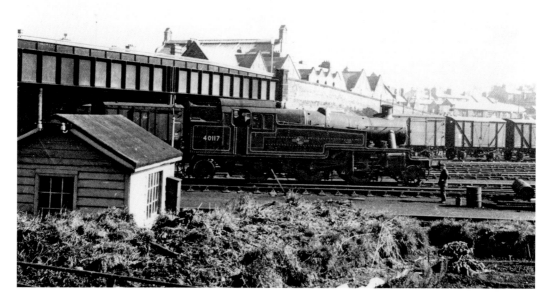

Tales of Wykeham Street Bridge

The original Wykeham Street Bridge was a wooden structure carrying a footpath over the newly built S&WR in 1885. It connected Wykeham Street on the west to Reston Street, on the east side, but when the wrought-iron road bridge (above) was built in the 1890s Reston Street was renamed to become part of Wykeham Street. By the time the present concrete bridge was built most of the railway tracks had been lifted. It now spans the start of the S&WR trailway, a popular route for cyclists and 'walkies'!

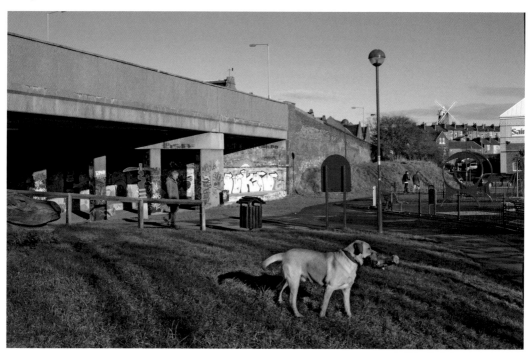

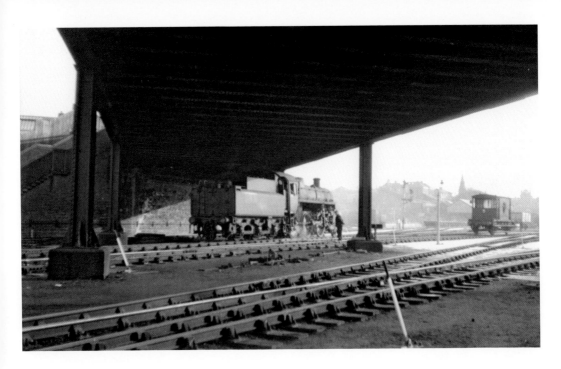

Underneath the Arches

Beneath Wykeham Street Bridge locomotives and trains once provided great interest for local railway enthusiasts as the amount of traffic in the goods yard, hauled in and out by a variety of engines, was interspersed with passenger trains to and from Whitby, and in summer by a number of special excursions. Now the stark lines of the new bridge are relieved by the colourful and imaginative work of the graffiti artists.

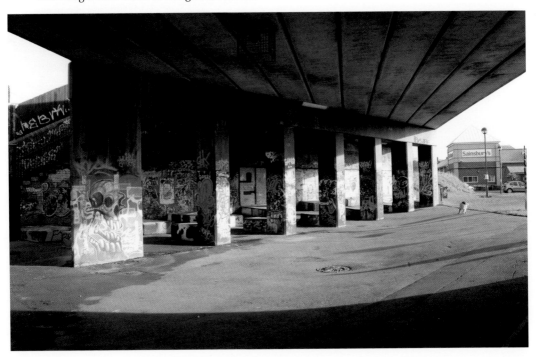

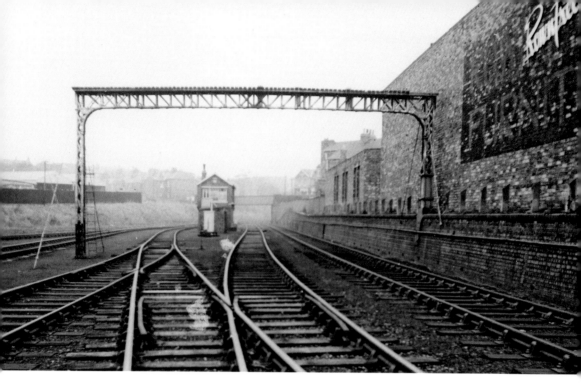

Art Off the Rails

The view looking north from beneath Wykeham Street Bridge shows Gallows Close signal box, Rowntree's furniture storage depot, and the redundant gantry that once supported the signals that controlled traffic movement in the sidings and along the S&WR. More colourful graffiti brighten the walls alongside the area that is now reserved for ball games next to Gladstone Road School. Compare this rather desolate scene with those of the same area on the opposite page.

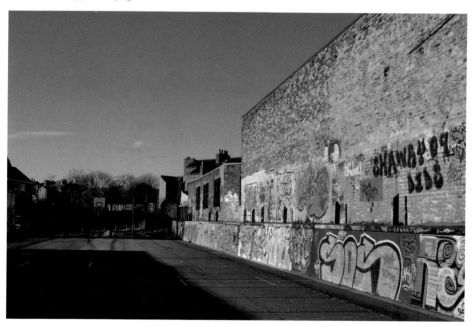

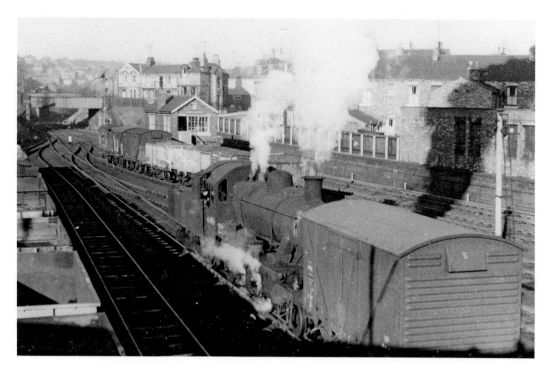

A Line for all Seasons

The sidings in the goods yard extended north of Wykeham Street Bridge and past the signal box in order to accommodate long goods trains. On one occasion a train of fifty-four wagons appeared through the tunnel from Falsgrave – it must have caused a headache for the signalman and shunters! The snowy scene provides a close-up of the signal box in January 1965, prior to the closure of the S&WR. Beyond the signal box Hibernia Street Bridge crosses over the line.

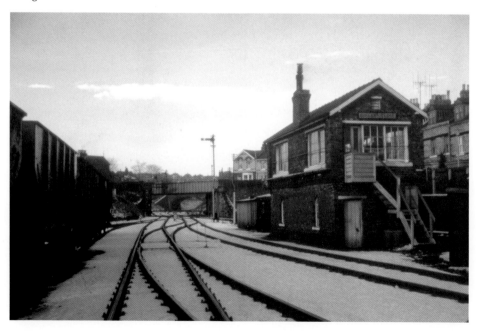

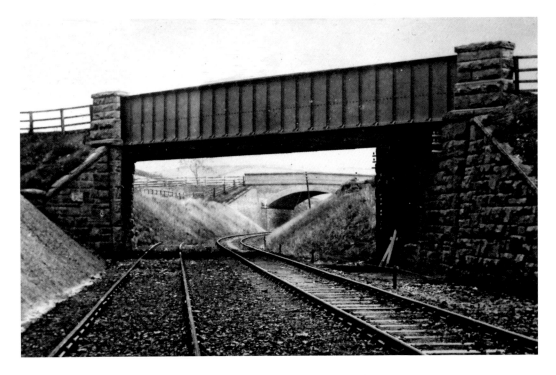

A Line of Bridges

In these photographs the bridge in the foreground carried Hibernia Street over the line and beyond that Manor Road Bridge spanned the tracks. The old photograph was taken in 1886, before most of the houses were built on the west side of the line. Hibernia Street Bridge was completed in July 1884, a year before the opening of the line but deterioration has now caused it to be closed to all but pedestrian traffic. There were a total of sixty-one bridges on the S&WR.

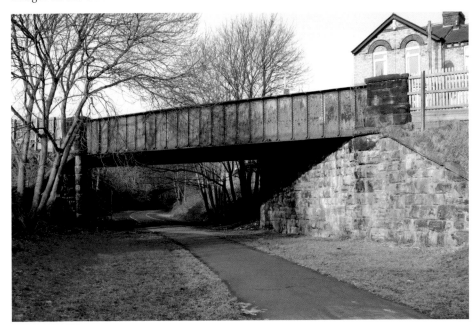

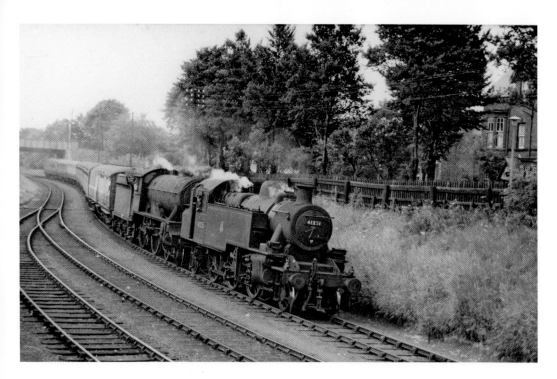

Approaching Woodland Ravine Bridge

The line here ran parallel to Manor Road and the next bridge that comes into view is at Woodland Ravine. The passing excursion train is double-headed as the steep gradients meant that trains of more than five coaches required the power of a second engine. The tracks approaching the bridge reduce to two lines – the single track S&WR on the right and, on the left, the line to Gallows Close (Northstead) Carriage Sidings opened in 1908 in conjunction with the opening of Londesborough Road Excursion Station.

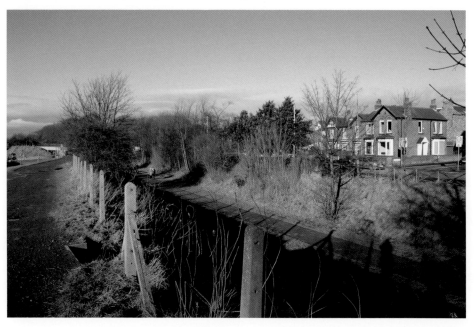

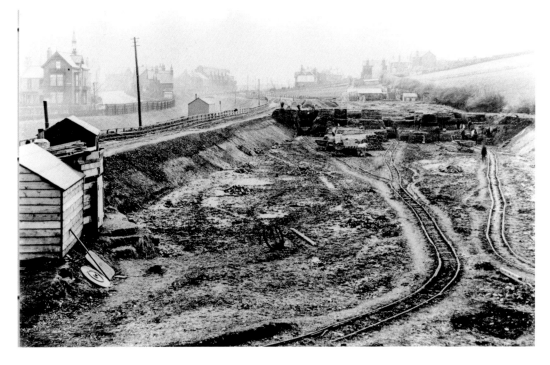

Building Woodland Ravine Bridge

Woodland Ravine Bridge was built in the late 1920s in conjunction with the building of the Prospect Mount and Barrowcliffe housing estates. The upper photograph was taken during the course of its construction when earth was excavated from Duggleby's Field to form the embankments. As the railway had been built in a cutting the excavation for the bridge left the footpath between the field and the railway appearing as if it had been made on an embankment.

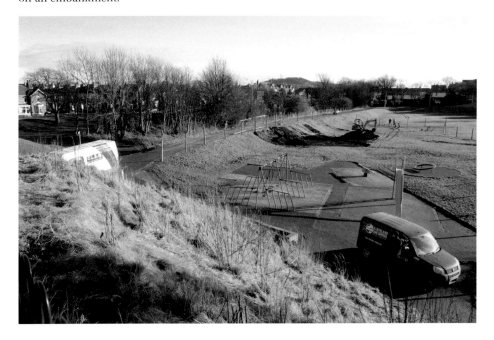

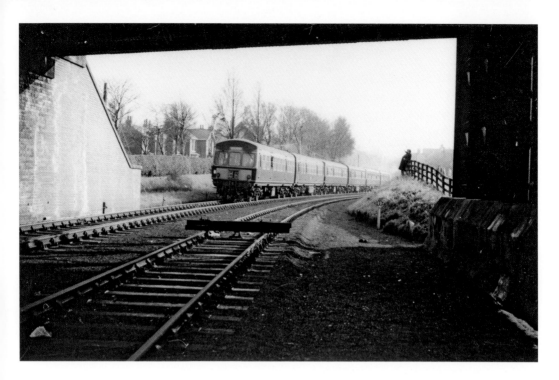

A change of pace at Woodland Ravine Bridge

The bridge has been rebuilt in recent years but the new one is in line with the footpath (seen on the previous page) and the trailway takes a slight detour at this point. The original bridge had wrought iron spans, the present one is in concrete with lights over the footpath. The top photograph was taken on the last day of passenger traffic when a six-car DMU headed for Whitby. The line up to the carriage sidings had been blocked off as Londesborough Road Excursion Station closed in 1963.

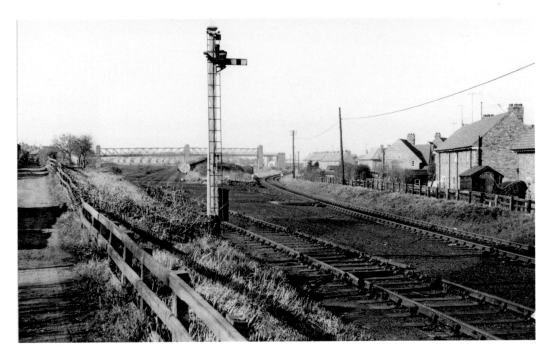

Gallows Close (Northstead) Carriage Sidings

The extensive carriage sidings at Northstead provided coaling, watering and turning facilities for the excursion trains using Londesborough Road Station. The present trailway follows the line of the S&WR round the east side of this area whilst the line near the signal ran independently up to the sidings. The area is now grassed over and the huge footbridge, seen in the distance in the top photograph, used to connect the Northstead and Barrowcliffe estates but was demolished a few years ago.

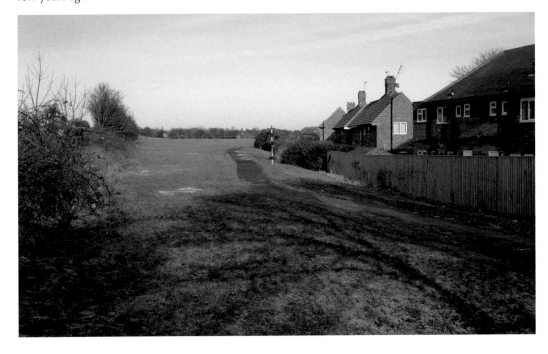

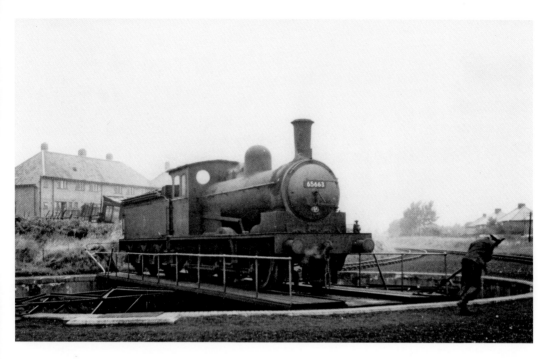

Swings and Roundabouts at Northstead

Towards the north end of the carriage sidings there was a turntable capable of turning the larger locomotives used on the excursion trains. It took quite a bit of effort by the footplate staff to turn the engines if they were not balanced correctly on the turntable. The position of the turntable can still be seen as the pit in which it sat was filled in and a children's playground put on the site next to the headquarters of the Gallows Close Playing Fields Association.

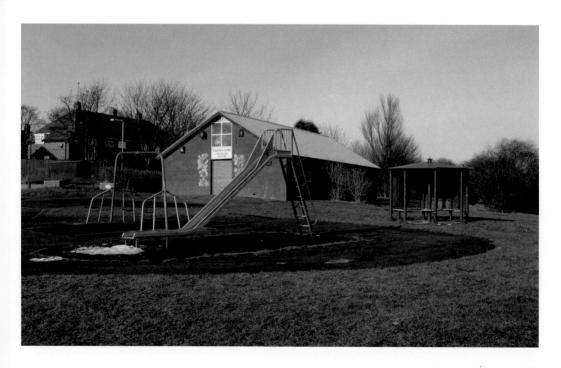

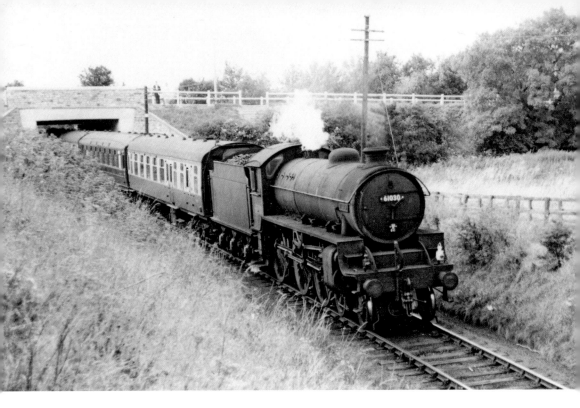

In the Cold at Coldyhill

Cross Lane Bridge, at the end of Coldyhill Lane, is at the northern end of the former carriage sidings site. The road over it was widened and levelled in 1961 and a new span built on the south side as seen in these photographs. The original bridge still stands and is visible from the north side and underneath. The new houses on a cul-de-sac off Cross Lane can be seen adjacent to the trailway on the recent photograph.

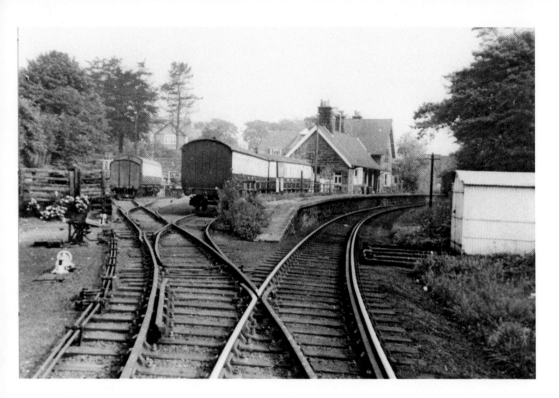

Scalby Station: a view from the viaduct

Scalby was the first of the eight stations on the line and it was approached from the south by a small 4-span brick-built viaduct that still stands. The station was a very attractive building of local stone with a slate roof. There was no passing loop here but it did have a small goods yard with a horse dock and carriage landing. Space on this site was so tight that the points for the goods yard were on the end of the viaduct.

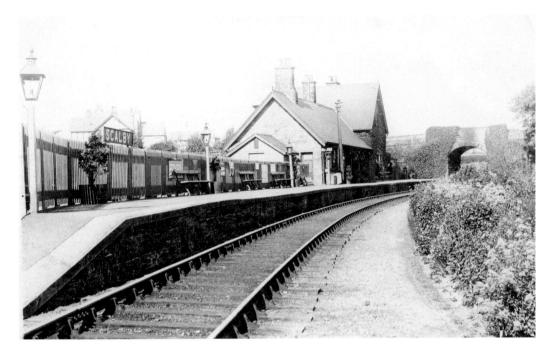

Scalby Station: from railway line to washing lines

This station, two miles from Scarborough, closed in 1953, twelve years before the whole line closed in 1965. The early photograph was taken in about 1905 and shows the picturesque hump-backed ivy-covered bridge that carried Station Road over the line. It was subsequently demolished, along with all the station buildings, and a small housing estate built on the site. Now, behind the houses of Chichester Close, the railway line has been replaced by washing lines!

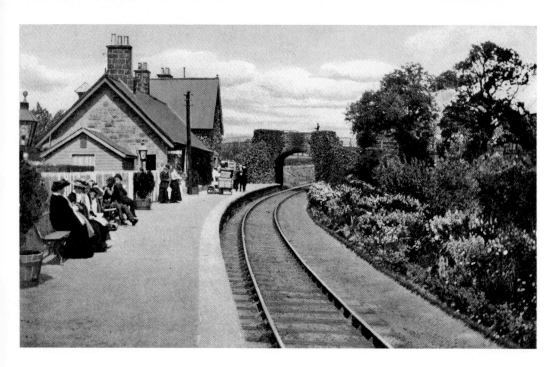

Scalby Station: from delight to destruction

This delightful scene, from an old coloured postcard dated 1914, shows the station at its most picturesque with a crowd of people waiting for the train and admiring the well-kept station garden on the other side of the single line. This is a complete contrast to the sad scene in 1974 when demolition of the station had just started, the track had been lifted, and it was the 'end of the line' for Scalby Station.

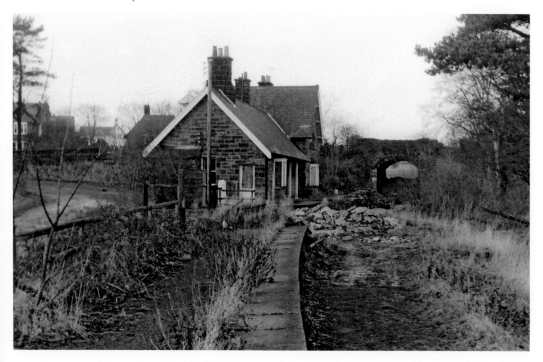

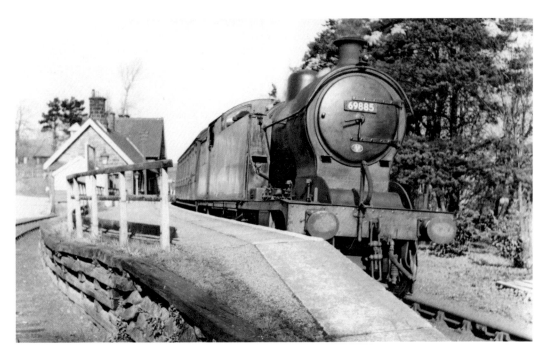

Scalby Station: changing trains

A contrast in trains at Scalby Station – for most of the life of the line the ordinary passenger trains were hauled by a variety of tank engines but in 1958 DMUs were introduced (see page 51). The upper photograph was taken on 28 February 1953, the day that the station closed for passenger traffic. The lower photograph was taken in 1961, eight years after the station closed, when the weeds were beginning to take over.

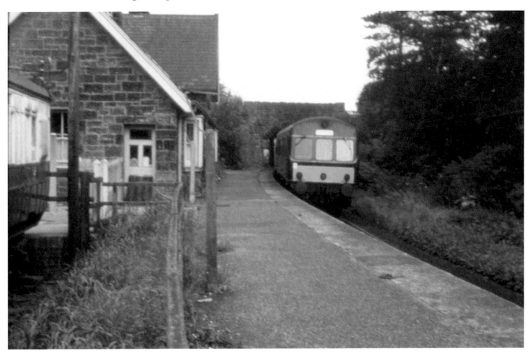

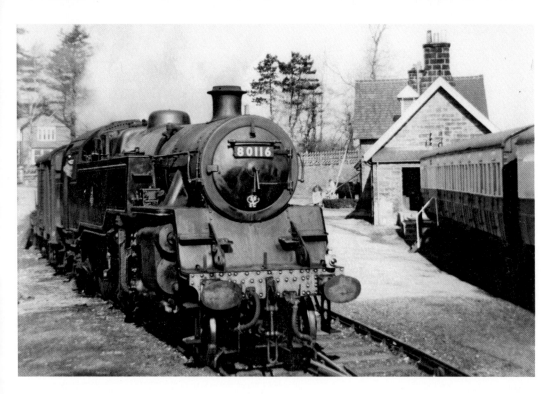

Scalby Station: images of steam and snow

A locomotive simmers gently in the small goods yard in 1956 having brought a couple of wagons on the 'Whitby Goods', a service that was still running despite the closure of the station to passengers. The station house was occupied for a time by George Sollitt who had worked at a number of stations in the area. Where the locomotive once stood there are now the gardens of Chichester Close and it is hard to believe there ever was a station here.

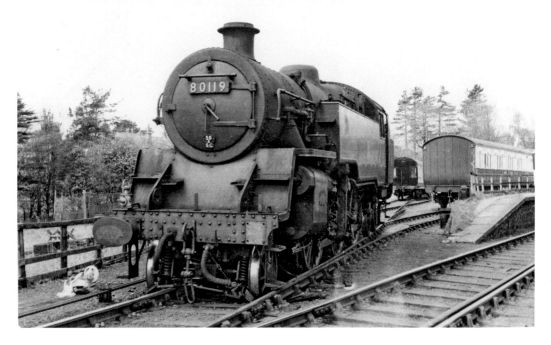

Scalby Station: off the rails

The goods yard has caused problems for staff and locomotives over the years with a number of derailments being recorded. On this photograph, taken in April 1956, the engine has come off the rails at the entrance to the goods yard. It was so close to the line through the station that, in order to allow passenger trains past, it had to have its nearside buffer removed. The only wheels in this area now are those of the cars in Chichester Close.

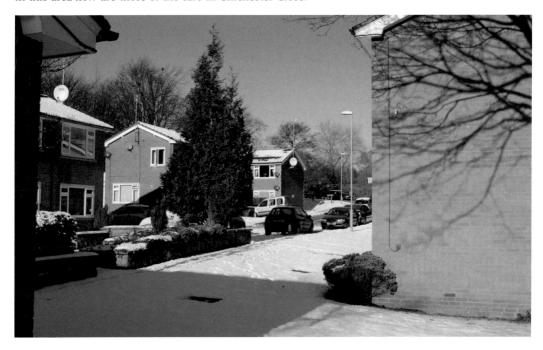

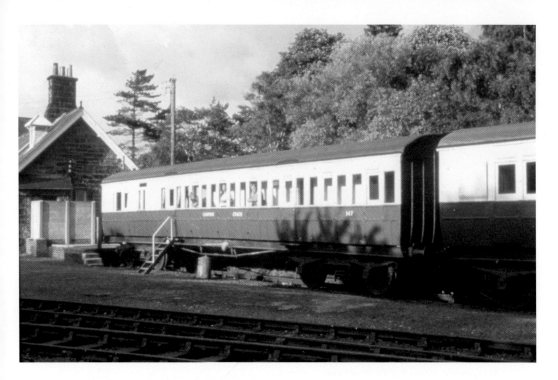

Scalby Station: camping on the rails

Camping coaches were introduced by the LNER in 1933, using small five-compartment vehicles, but were withdrawn in 1939. They were reintroduced by British Railways in the 1950s, using larger coaches, and these two at Scalby were photographed in 1961. Rental for a coach was between £5.50 and £7.50 per week and each coach could accommodate six people. They included a fully equipped kitchen, a commodious living room and three bedrooms. All the coaches were provided with bed linen, cooking utensils, towels, crockery, cutlery, and table linen.

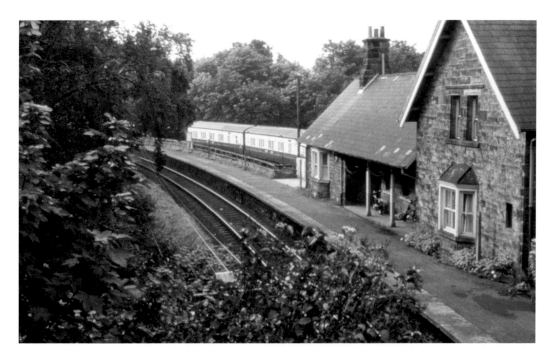

Scalby Station: destined for destruction

A view from the hump-backed bridge in 1961 shows the station after closure although the camping coaches were still in use. Whilst passenger traffic had ceased here the occupants of the camping coaches could request trains to stop if they wished to travel on the line. Camping coaches could only be booked if the party purchased four adult return rail tickets from their home to the camping coach station. The scene changed drastically in 1974 when the station buildings were in the final stages of demolition.

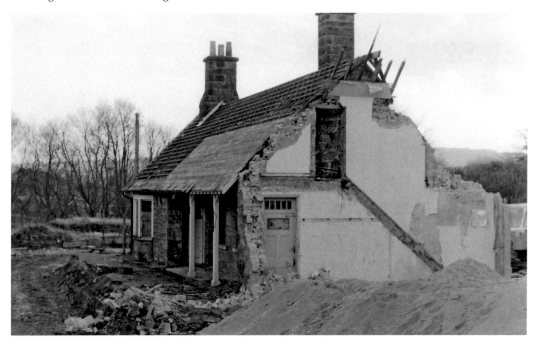

Scalby Station: a view from Station Road

The gated entrance to the station yard, and the ivy-clad station house, can clearly be seen on this postcard photograph dated May 1918. The hump-backed bridge was demolished at the same time as the station and both have vanished almost without trace. In the recent photograph the houses in Chichester Close nearest to the road incorporate stones, on the outer corners of the buildings, reclaimed from the original station building. These can be seen on the building in the centre of the photograph.

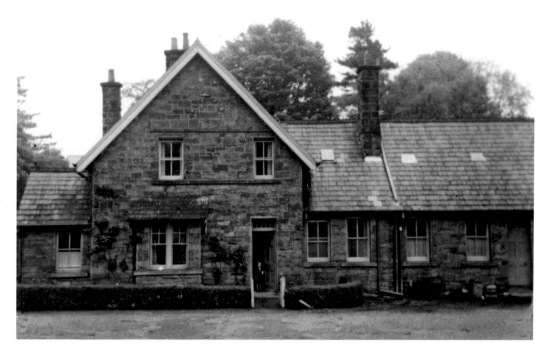

Scalby Station: destination dismantled

The design of the larger stations on the S&WR follows the same basic plan but there are some interesting variations that can be seen by comparing Cloughton, Stainton Dale, Robin Hood's Bay and Hawsker. Here the two-storey station master's house was at the north end of the station with the single storey section housing the waiting rooms and offices, on the south. Evidence of its solid construction could be seen when the station was demolished in 1974 – some of the stone walls were 18 inches thick.

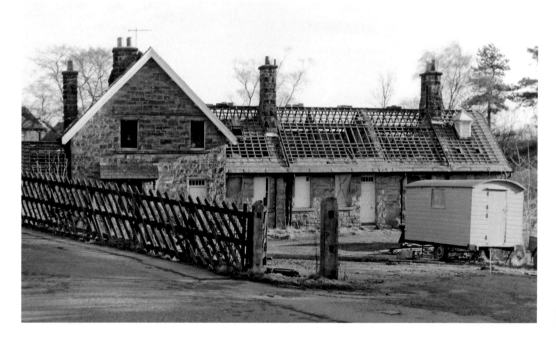

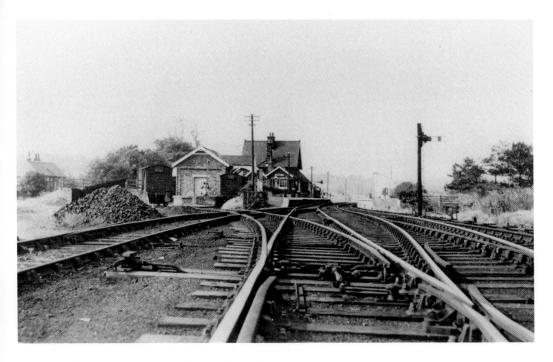

Cloughton Station: a view from the south

The southern approach to Cloughton Station has seen some remarkable changes. Where there was once an open aspect of all the station and its facilities – a passing loop, two platforms, a goods yard with cattle dock, and goods shed with wooden canopies – there is now a sylvan scene with a holiday camping coach standing at the platform. Just to the left of the coach is the gable end of the goods shed that can be seen on left of the telegraph pole on the upper photograph.

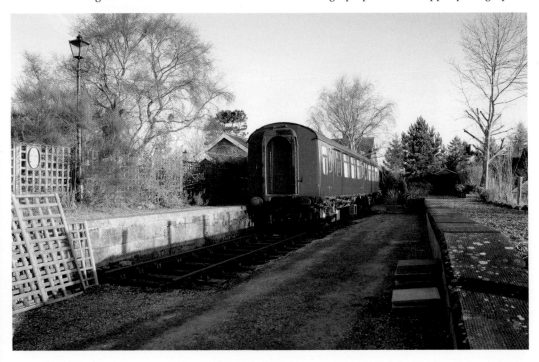

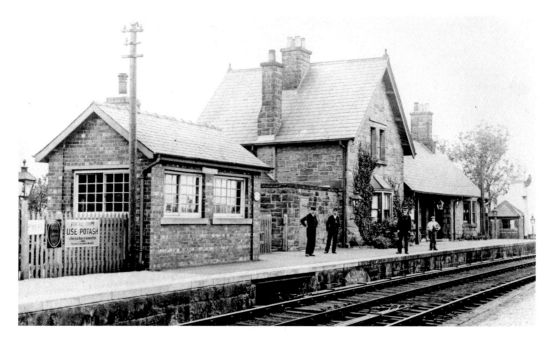

Cloughton Station: a delightful destination then and now

The design of Cloughton Station was similar to that at Scalby but the plan was reversed with the two-storey station master's house at the south end and the single-storey waiting rooms and offices beyond. On the left the signal box has been replaced by a large extension that includes holiday accommodation for visitors. The station now has a popular tea room with access to the platform and extensive landscaped garden – a pleasant place for a cream tea on a summer afternoon!

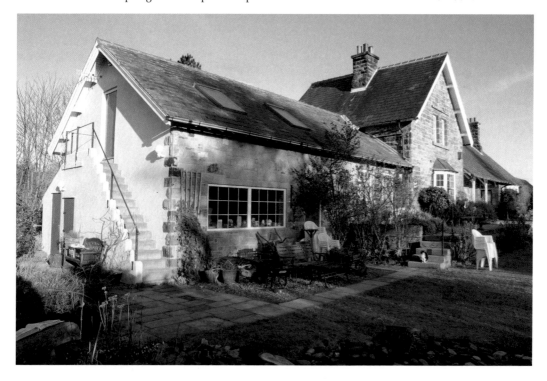

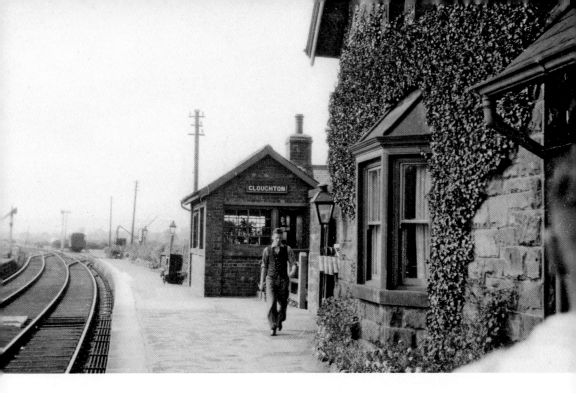

Cloughton Station: a stroll along the platform

Looking along the platform, in the 1930s, the line ran south towards Scalby and, in the distance, past the camping coaches in their own siding (see page 47). In the centre is the signal box and on the right the bay window of the station master's house. Note the platform lamp and row of fire buckets just beyond the window. The room with the bay window now contains the tearoom, with displays of photographs and ephemera, and patrons, not passengers, can now stroll along the platform.

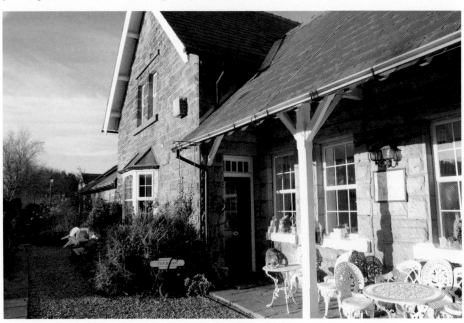

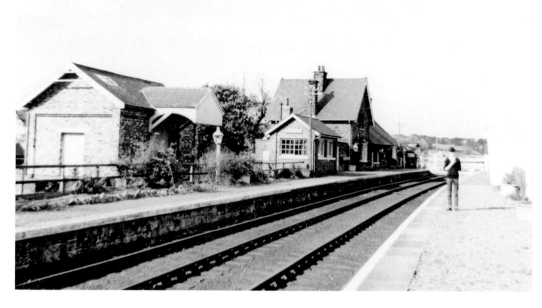

Cloughton Station: memories are just the ticket

Cloughton Station originally had a single platform with a parallel siding (the line on the right) and it was not until 1891 that the siding was joined up, to form a complete passing place, and a second platform added. The group of tickets, including ones to and from Cloughton, represent all the eight stations on the S&WR . The three on the bottom row are typical of the many different excursions that ran over the line in the 1950s and '60s.

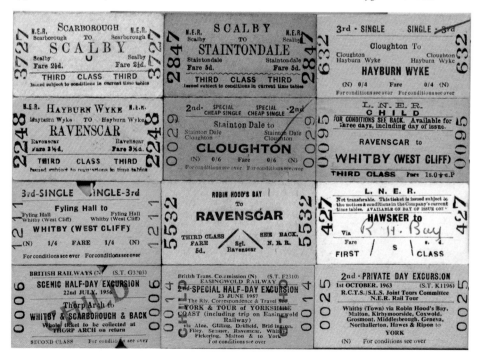

Cloughton Station: camping in a siding

LNER camping coaches at Cloughton, in the 1930s, were very different to the British Railways camping coaches of the 1950s (see page 39). The LNER coaches were old five-compartment six-wheelers that were converted into a kitchen, day room and two sleeping compartments. Hire of a coach for a week was £2.50 for up to six people. The coaches were on the long siding south of the station (see page 45) and the lower photograph shows the view from a coach looking back towards the station.

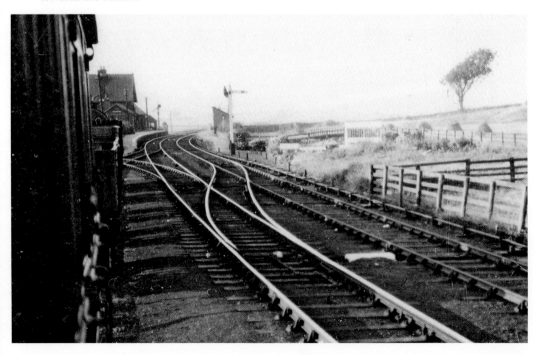

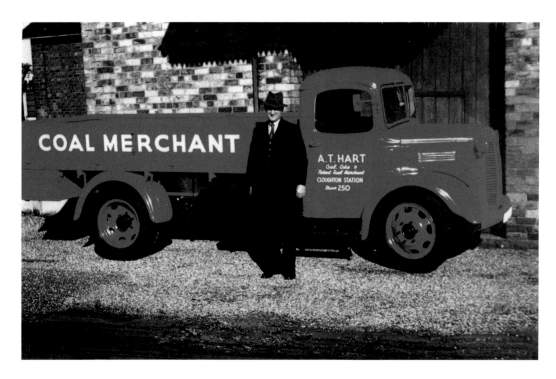

Cloughton Station: from warehouse to holiday home

Alf Hart, the last station master, stands in front of the old goods warehouse in the yard at Cloughton Station with his shiny new Bedford coal lorry. He would still recognise the old goods warehouse now although it has been transformed from an 'industrial' building into holiday accommodation with the addition of a small extension on the right. The wooden canopies have been restored and the entrance redesigned in a manner which enhances the simple design of the original building.

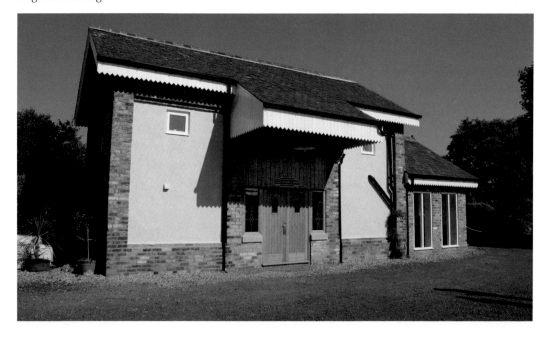

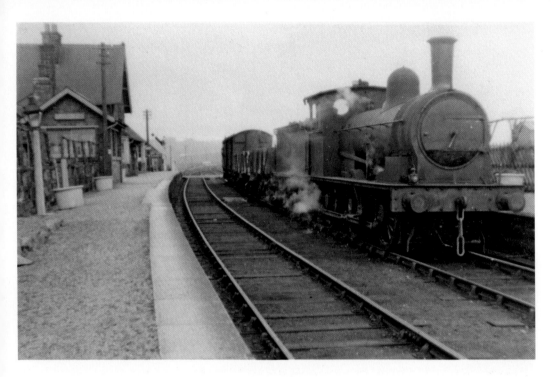

Cloughton Station: long goods and last passengers
A daily goods train ran on the S&WR for many years but in later days it often consisted of just two or three wagons. The goods train featured on the upper photograph was being hauled by a steam locomotive in 1948 but diesel shunting engines were used prior to closure (see pages 74 and 83). The lower photograph was taken on the last day of passenger traffic when two DMUs passed each other, the one on the left heading for Whitby the other coming towards Scarborough.

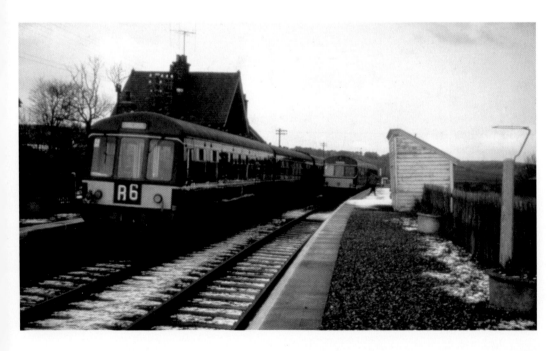

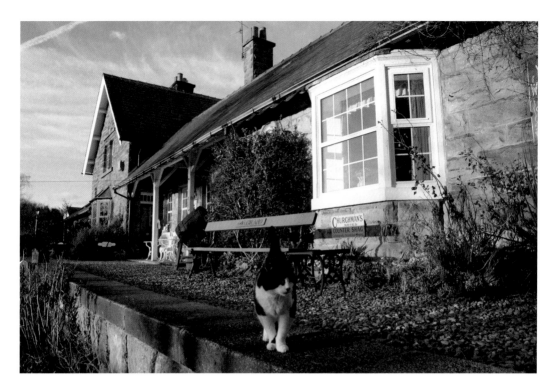

Cloughton Station: a view from the level crossing
In the early morning sunshine the friendly station cat prowls the platform to investigate whether the intruding photographer is a likely source of an early breakfast! This station had the only public level crossing on the line and the gates were worked by a wheel in the small hut behind the signal. This is now fenced off and the public right of way for walkers and cyclists is through the former goods yard to rejoin the trailway south of the station.

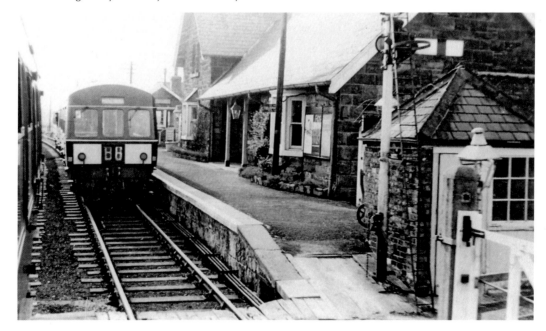

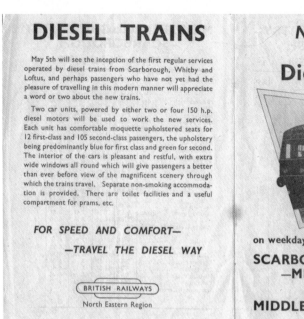

DIESEL TRAINS

May 5th will see the inception of the first regular services operated by diesel trains from Scarborough, Whitby and Loftus, and perhaps passengers who have not yet had the pleasure of travelling in this modern manner will appreciate a word or two about the new trains.

Two car units, powered by either two or four 150 h.p. diesel motors will be used to work the new services. Each unit has comfortable moquette upholstered seats for 12 first-class and 105 second-class passengers, the upholstery being predominantly blue for first class and green for second. The interior of the cars is pleasant and restful, with extra wide windows all round which will give passengers a better than ever before view of the magnificent scenery through which the trains travel. Separate non-smoking accommodation is provided. There are toilet facilities and a useful compartment for prams, etc.

FOR SPEED AND COMFORT—
—TRAVEL THE DIESEL WAY

BRITISH RAILWAYS

North Eastern Region

McCorquodale & Co. Ltd., London, N.W.I. 86/45.

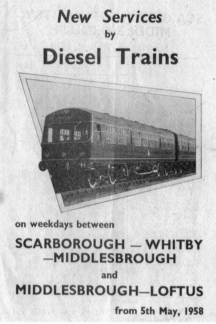

New Services
by
Diesel Trains

on weekdays between

SCARBOROUGH — WHITBY —MIDDLESBROUGH
and
MIDDLESBROUGH—LOFTUS

from 5th May, 1958

Modernisation: introducing diesels

Diesel Multiple Units were introduced on the S&WR in 1958 and operated the normal service trains on the line until closure in 1965. The upper illustration shows the front and back covers of a leaflet introducing the service to the travelling public. DMUs were also introduced on 'Sightseeing Day Tours by diesel train from Scarborough' in 1959 and the lower illustration shows the route of the circular tour that included the S&WR. The tours departed from Scarborough at 11.15am every weekday and the fare was 50p!

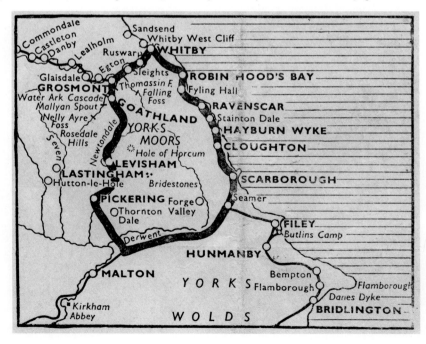

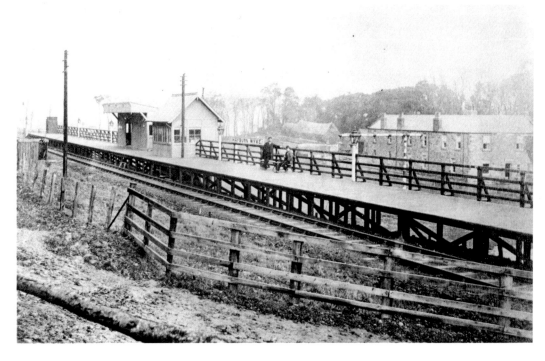

Hayburn Wyke: a moving station

The original station here, photographed in 1886, was built entirely of wood on the seaward side of the line, and was supported by a series of hefty timbers on the hillside sloping down towards the Hayburn Wyke Hotel. This arrangement was short-lived as the S&WR Co built a solid platform on the landward side of the line in 1893. On the colour photograph, taken in 1965, the separate brick-built station master's house, erected in 1892 at a cost of £330, can be seen beyond the station buildings.

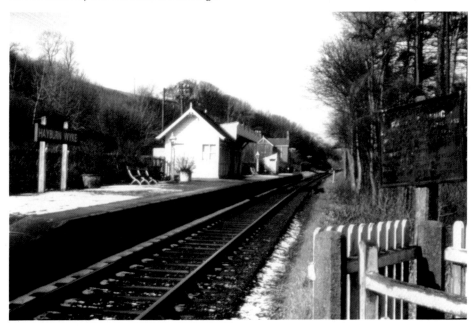

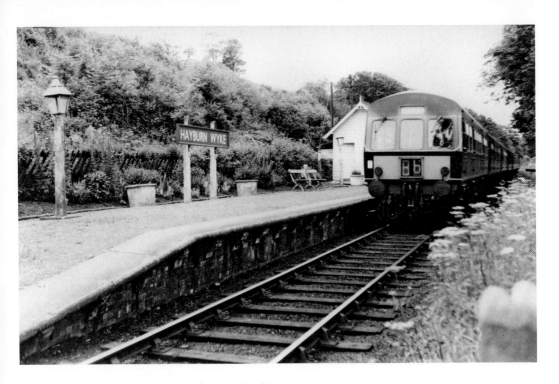

Hayburn Wyke Station: smallest on the line

A DMU stands at the single track station in July 1963. This was the smallest station on the line and the only one without a siding or goods yard. The station became an unstaffed halt in 1955 when the buildings were converted into a camping cottage. All the buildings were demolished after closure except the station master's house. The lonely concrete post, on the left, once supported the platform lamp seen in the top photograph.

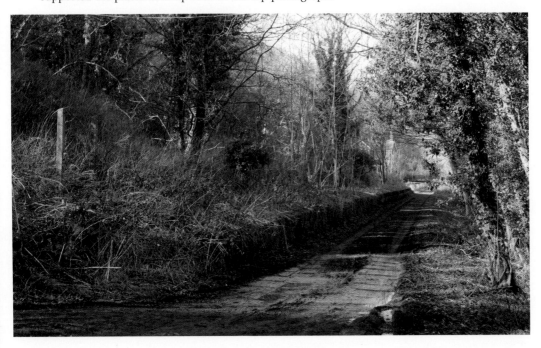

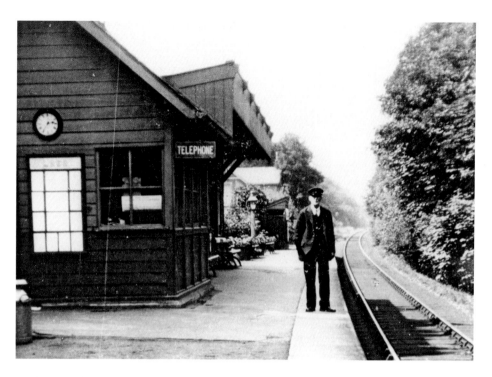

Hayburn Wyke Station: the lonely life

Hayburn Wyke was popular with day trippers and picnickers but for most of the year there were only about four trains a day in each direction increasing to eight in the summer months. There is now hardly a trace of the station – only the platform survives and the moss-covered rectangular outline of the booking office foundations can be seen amongst the saplings in the foreground. Immediately beyond that is a bright patch of snowdrops heralding the promise of spring after a long hard winter.

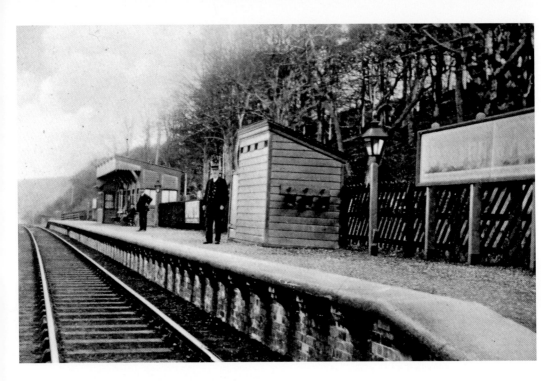

Hayburn Wyke Station: from the north

Beyond the name board and the platform lamp is the gentlemen's convenience and beyond that the canopied waiting shelter that also appears in the colour photograph. This was taken in October 1967 when a special train of two guard's vans, hauled by a diesel shunting locomotive, stopped at the station. The train brought the contractors up the line who were going to tender for the redundant assets of the closed line. This was the very last train to run on the railway, two years after closure.

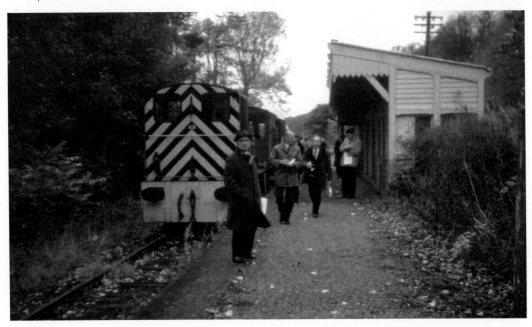

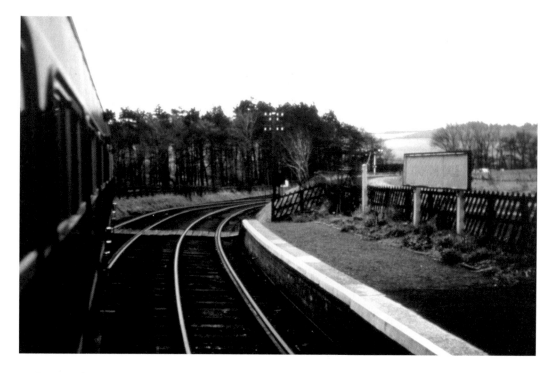

Stainton Dale Station: south end

The gradient at the south end of Stainton Dale station dips sharply from 1 in 172 to 1 in 54 at the signal box (see page 58) and catch points were installed beyond the south end of the station to prevent vehicles running back onto the single line. The name of the station has appeared as 'Stainton Dale' and 'Staintondale' at various time over the years (see the tickets on page 46). Both platforms still survive at the former station, and the station buildings are now privately owned.

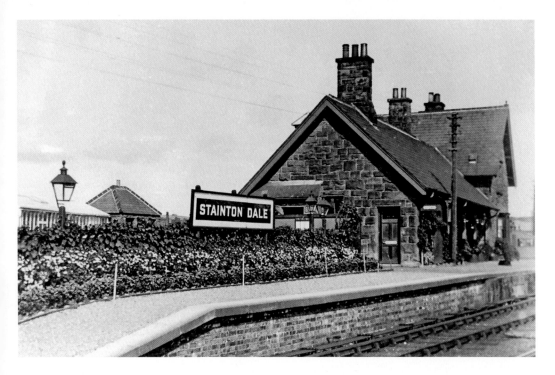

Stainton Dale Station: a picturesque gem

Despite the passing of time this station is still a picturesque gem on the S&WR and the two photographs, taken nearly a hundred years apart, show that the occupiers of the station have always cared for the building and its grounds. Between the platform lamp and the enamel station name sign can be seen the slate roof of the old weigh house that also appears on the recent photograph. Unlike Cloughton Station the trailway runs along the old track-bed between the platforms.

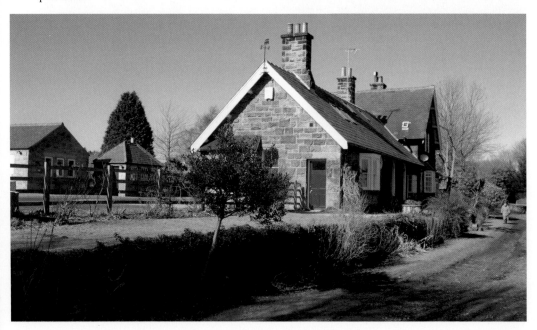

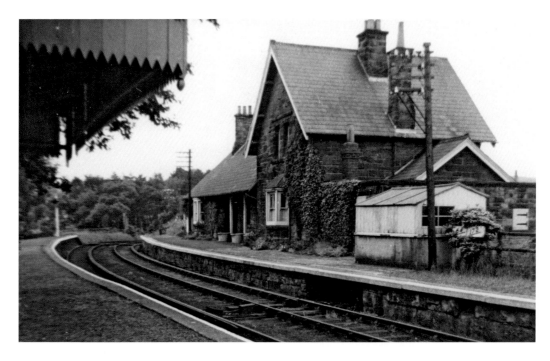

Stainton Dale Station: from the 'up' platform

The canopy of the wooden waiting shelter has been superseded by a canopy of trees providing shade for a 'contra jour' shot of the station buildings from the edge of the 'up' platform. The unusual wooden signal box, that had thirteen working levers, has been replaced by a sympathetic extension to the station house. Note the gradient board "1 in 54/1 in 172" on the fence next to the signal box, referred to on page 56.

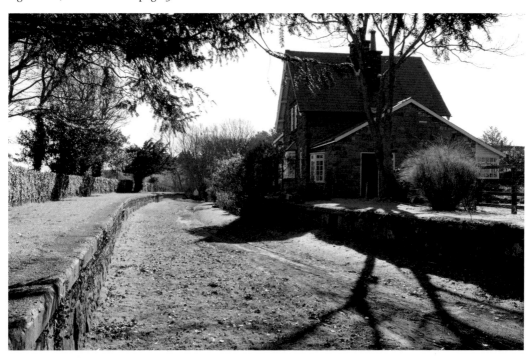

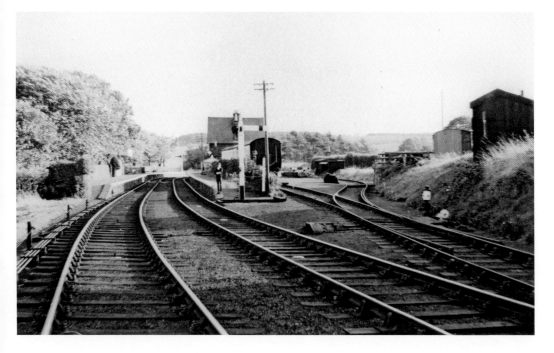

Stainton Dale Station: from the north

Stainton Dale station had a small goods yard dealing with a variety of agricultural products, and stone from a local quarry. In later days two camping coaches were stationed here, similar to those at Scalby station (see page 39), and these can be seen on the siding behind the signal. The present day view shows the original track bed on the left, and what is now the private entrance to the station property, formerly the goods yard, on the right.

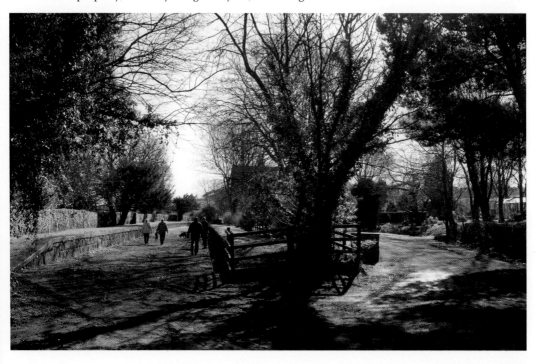

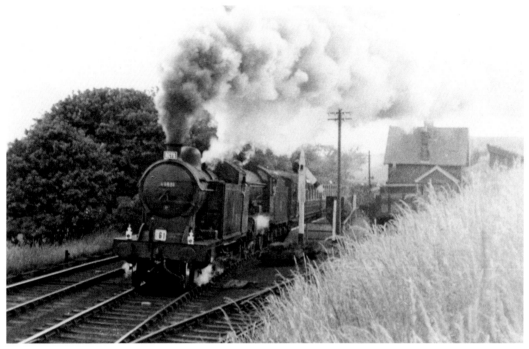

Stainton Dale Station: a signal success

A double-headed steam-hauled train storms past the down starter signal at the north end of Stainton Dale station in 1957. The view northwards from the same signal, in May 1965, shows the convergence of the goods yard line and the passing loop lines. Beyond this point the line rose at a steep 1 in 41 for two miles up to Ravenscar station, ten miles from Scarborough, and the highest station on the line at 631 feet above sea level.

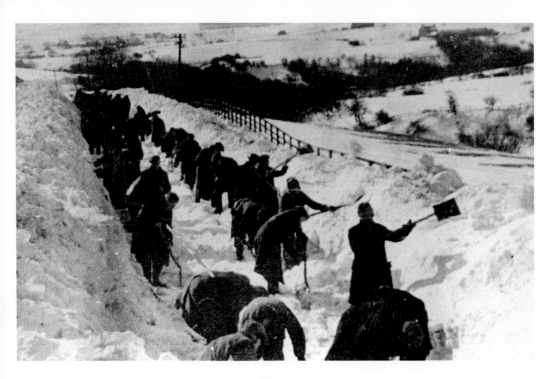

North of Stainton Dale Station: battling the elements

The bad winter of 2009/10 was not as severe as that of 1947 when some of the railway cuttings were filled with snow to a depth of 12 feet. A number of snow plough trains were sent to clear the line between Stainton Dale and Ravenscar but all failed so a gang of men from York were sent to dig their way to Ravenscar. No doubt they would have been pleased to see the Bovril sign at the station when they arrived tired but triumphant!

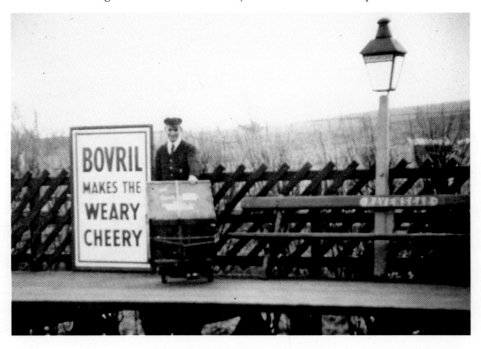

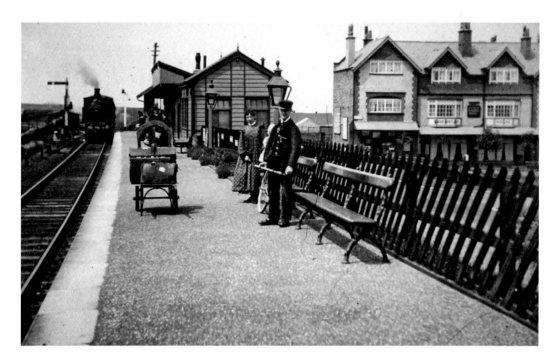

Ravenscar Station: on the right track

The station at Ravenscar was originally called 'Peak' when the line was opened in 1885 but this led to some confusion amongst rail travellers and some alighting here asked the staff to direct them to the Blue John Mines (in the Peak District!). It was renamed Ravenscar in 1897. The passing loop and wooden Whitby platform were added in 1908 shortly after the old photograph was taken. DMUs became very popular as, with wide windows, they provided a better view of the magnificent coastal scenery.

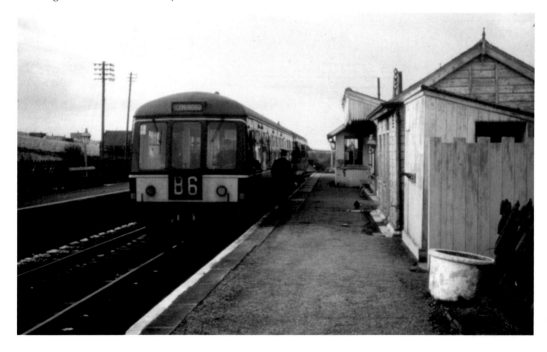

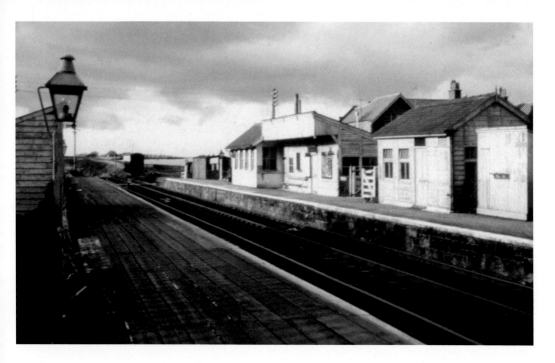

Ravenscar Station: a disappearance

The buildings at Ravenscar station were made of wood, apart from the brick-built signal box that was just beyond the canopied waiting shed that once blew away in a gale! All the buildings, and the wooden Whitby platform and shelter, were demolished after closure and only the solid platform on the 'up' side remains. This can be seen in the recent photograph together with the ivy-covered foundation of the waiting shelter, of the Whitby platform, that can just be seen amongst the bushes on the left.

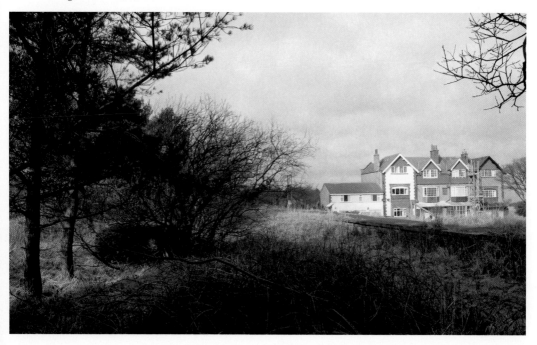

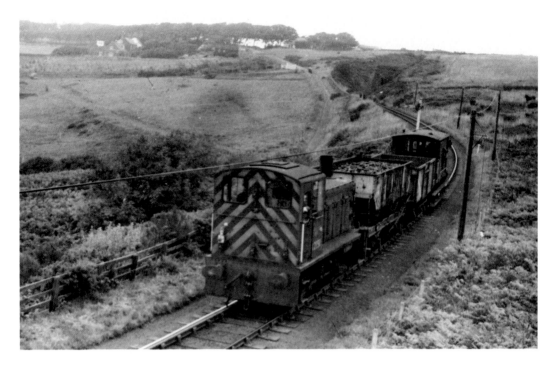

Ravenscar Bank: north of the tunnel

The last daily freight, in August 1964, had just emerged from Ravenscar tunnel that can be seen in the distance, above and to the left of the signal post. The tunnel is 279 yards long and has been blocked up as it is becoming dangerous. Walkers take a detour from Ravenscar Station to a point, near the original position of the signal post. The tunnel is no longer visible from here as the cutting has filled with trees and bushes since the lower photograph was taken in 1968.

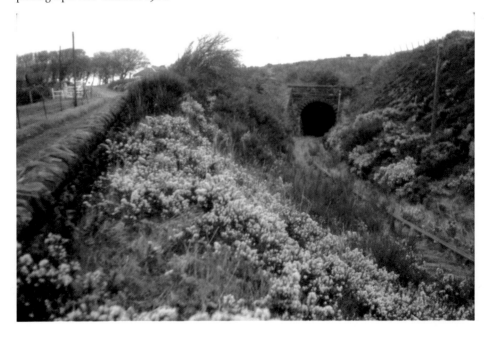

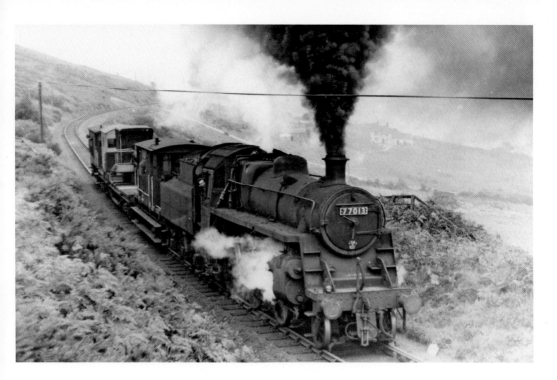

Ravenscar Bank: when the smoke clears...

A Bridge Inspection Unit heads towards the tunnel at Ravenscar, in September 1962, where it would no doubt spend some time whilst the crew examined the structure for signs of deterioration. The view from here, when the smoke cleared, is superb on a fine day as the lower photograph shows. Walking this section of the trailway between Ravenscar and Robin Hood's Bay, a distance of five miles, is well worth the effort with its magnificent views over the bay.

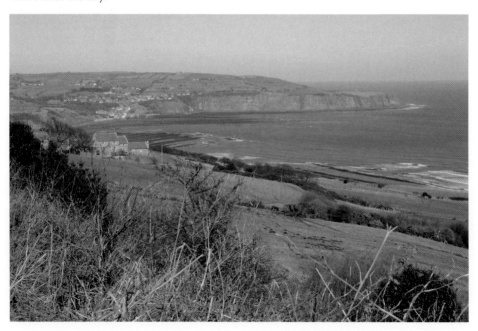

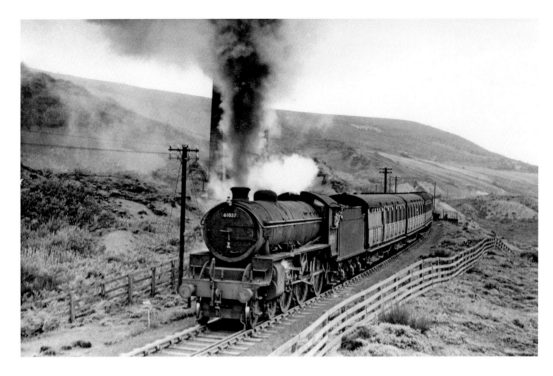

Ravenscar Bank: passing the brickworks

In 1900 Whitakers Brickworks opened here alongside the line and its chimney can be seen half-hidden by the smoke from a passing train. The brickworks were built in an old alum quarry and were provided with a siding for the transport of bricks away from the site. Road access was via the attractive stone and brick-built two-arch bridge in the lower photograph. This had been built originally to accommodate a tramway and a roadway to serve the estate of W. H. Hammond who lived at Raven Hall.

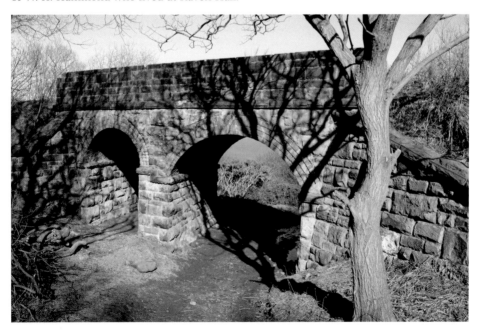

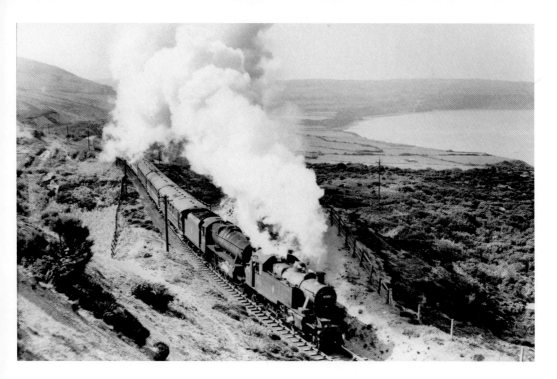

Ravenscar Bank: an enthusiast's delight

This view, from near the brickworks, was a magnificent sight with a double-headed steam-hauled excursion train working hard on the steep 1 in 39 gradient up to Ravenscar. Both photographs were taken from the spoil heaps left over from the working of the alum quarries that were in operation from about 1650 to 1850. The lower view looks in the opposite direction, southwards to Ravenscar, and the Raven Hall Hotel can be seen on the horizon towards the left hand side.

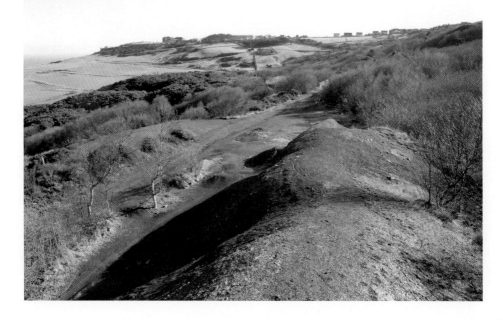

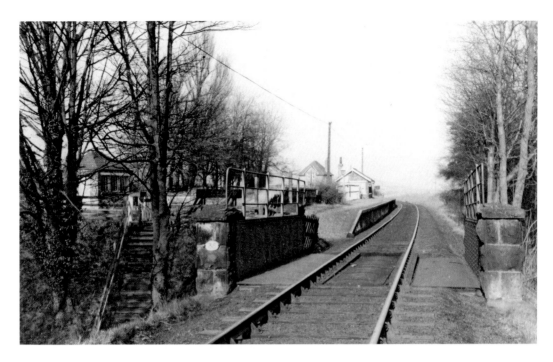

Fyling Hall Station: from bridge 35
The approach to Fyling Hall station was over this short wrought iron bridge with stone abutments. Although there was no passing loop here there was a small goods yard with a weigh house that can be seen through the trees on the left. The station is now quite difficult to find as trees and bushes have grown up hiding the platform from view especially when the vegetation is in leaf. The bridge has been replaced by steps leading down to Fyling Hall Road.

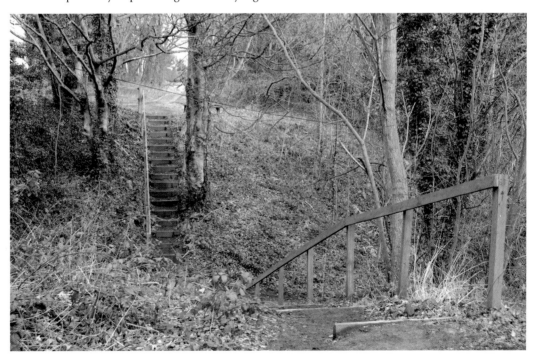

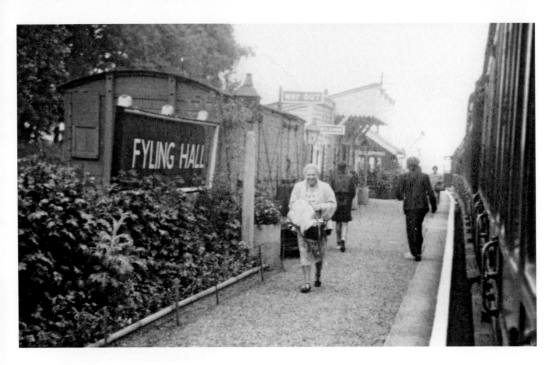

Fyling Hall Station: calling a halt

In its heyday Fyling Hall was a very attractive station with well-kept gardens, tidy platform and bright paintwork. On the left a railway van body was used as a goods warehouse and beyond that is the ticket office, the canopied waiting shelter, and at the far end the brick-built signal box. All this changed in 1958 when the station was converted into an unstaffed halt. With the removal of all the wooden buildings the station looked a sorry sight in October 1964.

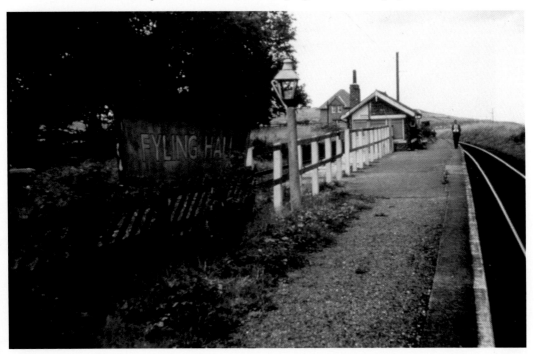

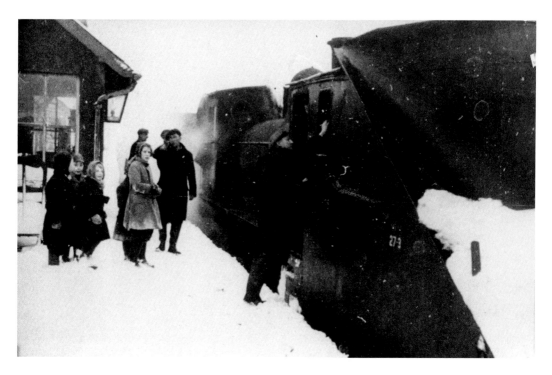

Fyling Hall Station: the changing seasons

These two photographs show the signal box in winter and in summer at Fyling Hall station. The snow plough was a welcome sight at the station in 1947 when the line was closed for two weeks between Ravenscar and Stainton Dale and the buses ceased running for eight weeks. The summer scene shows that the porter-signalman here, Albert Hunter, was a very enthusiastic gardener and by the end of July he could hardly see out of his signal box for all the blooms!

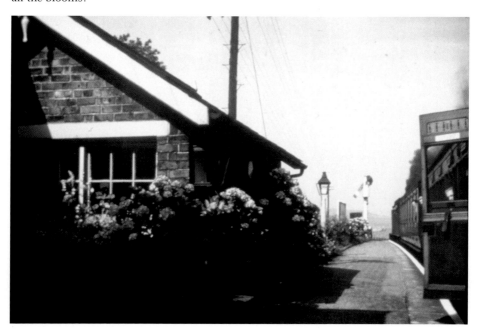

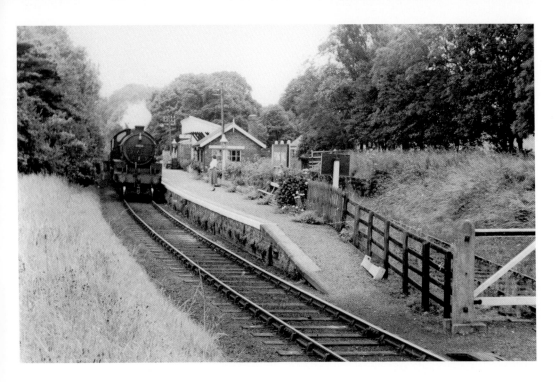

Fyling Hall Station: a tranquil scene
The view from the north end of Fyling Hall station shows the access to the goods yard through the gate on the right. The trailway diverts through the yard and rejoins the track-bed on the other side of Fyling Hall Road. The platform has practically disappeared in the mass of trees and bushes that have grown up since the line closed. In the upper photograph the concrete gatepost is the same one that is covered in ivy in the centre of the lower photograph.

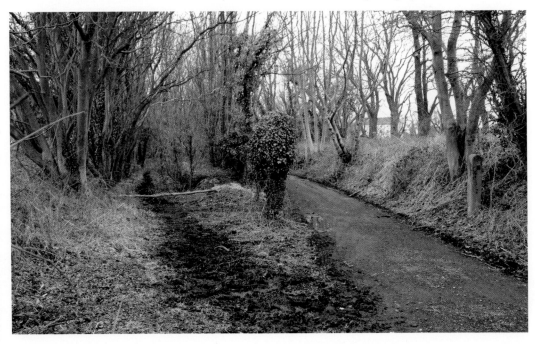

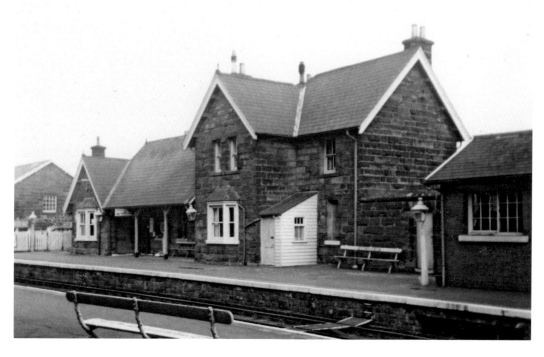

Robin Hood's Bay: the largest station

The station buildings in 1959 with, right to left, the signal box, the two-storey station master's house, and the single storey waiting rooms and booking office. On the far left the separate goods warehouse has been incorporated into the new village hall (see page 76). Most of the buildings are now in private ownership and have a variety of uses. In the lower photograph the former post office and refreshment room, built of wood, is still attached to the former signal box (see page 74).

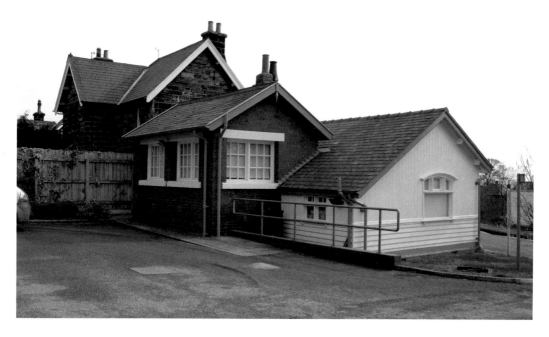

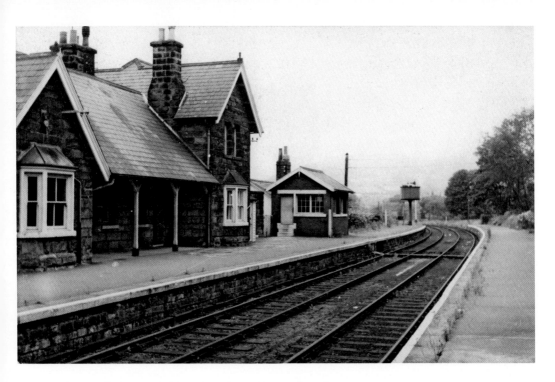

Robin Hood's Bay Station: a view from the north end

Taken only a few weeks apart, in 1965, these photographs show that the weeds were beginning to take over, along the platform edge, just a few months after closure. This was the largest and busiest station on the line with a coal yard, cattle dock, weighbridge, goods warehouse and crane, and water columns to replenish the tanks of the steam locomotives. Camping coaches were stationed here at the south end of the station on a specially built siding (see page 75).

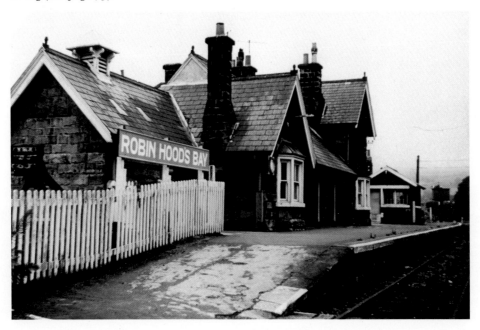

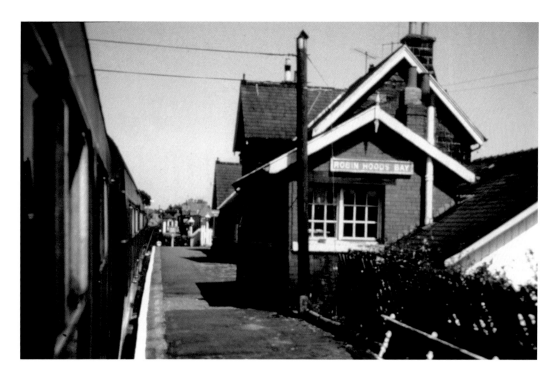

Robin Hood's Bay Station: passing the signal box

Two very different trains pass the signal box at Robin Hood's Bay in 1964. The upper photograph is taken from a loco-hauled passenger train on its way down to Scarborough and the lower one shows the last freight train on the line on 4 August. The wooden building adjacent to the signal box was the Post Office & Refreshment Room built in 1904/5. The attractive building still exists and has had a number of uses since closure.

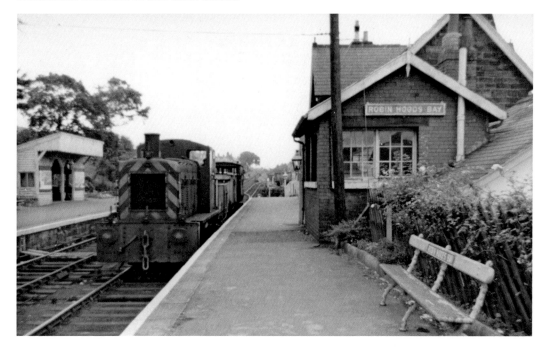

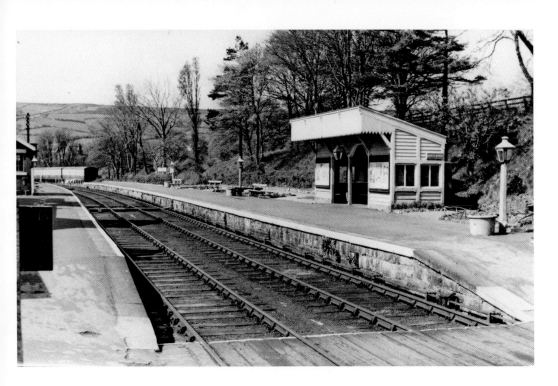

Robin Hood's Bay Station: quiet moments
In the upper photograph the waiting shelter on the 'down' platform stands out clearly in the morning sunshine and in the distance camping coaches stand on their own siding. Camping coaches could be hired for one or two weeks, from April to October, and had three bedrooms each with upper and lower bunk beds. The last station master, Bob Ascough, was a well-respected gentleman, and appropriately, is standing near to the 'gentlemen' sign on the side of the waiting shelter.

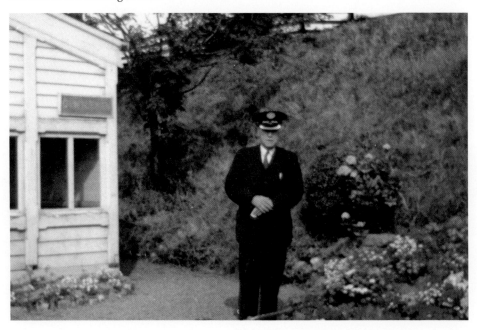

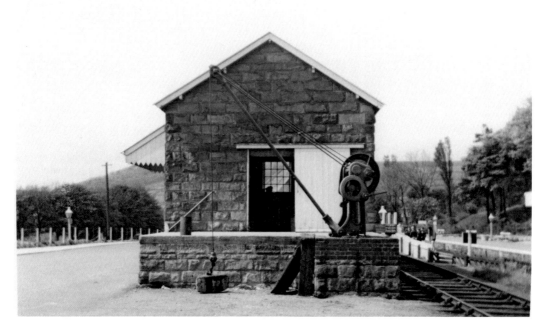

Robin Hood's Bay Station: a goods warehouse transformed

Robin Hood's Bay was a very busy station with thousands of holidaymakers and day trippers in the summer, and with a great variety of goods traffic. The large goods warehouse and its crane were kept busy throughout the year with agricultural and domestic traffic. After closure the goods warehouse was remodelled and incorporated into the new village hall that occupies the site across the railway track-bed. The two stone brackets that supported the wooden canopy can still be seen on the left-hand wall in the recent photograph.

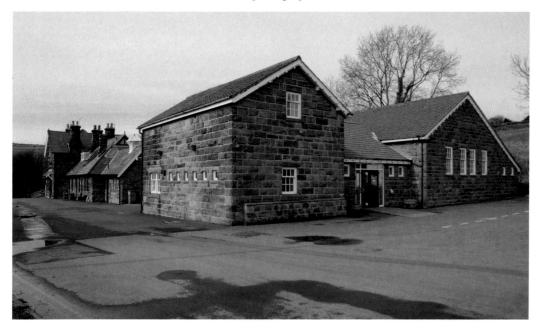

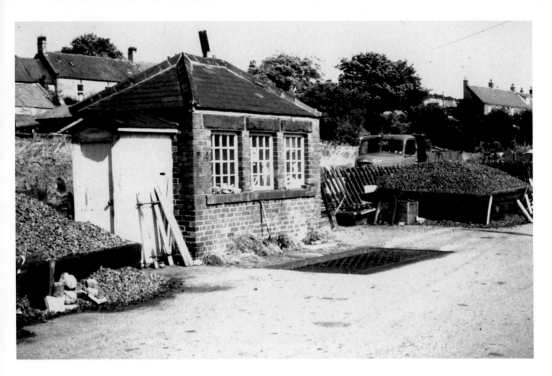

Robin Hood's Bay Station: changes in the coal yard

There was a considerable amount of coal traffic into Robin Hood's Bay station, second only to that at Cloughton. The coal business continued after the line closed and this photograph shows the weigh house and yard in 1967. The business was later moved to the south end of the station, the weigh house demolished and the area cleared to make way for a car and coach park. The earlier view shows the coal yard and weigh house from the end of the siding behind the goods warehouse.

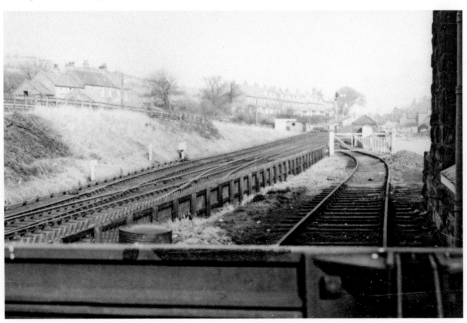

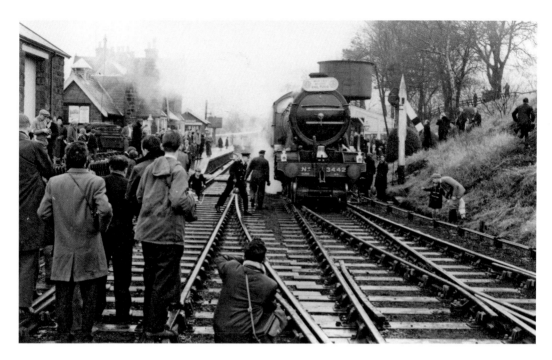

Robin Hood's Bay Station: preludes to demolition
On the last day of passenger traffic on the line, on 6 March 1965, the Manchester Locomotive and Stephenson Locomotive Societies ran a special excursion – the 'Whitby Moors Rail Tour' over the line. It was a scene of chaos with enthusiasts and local people wandering all over the tracks to take their final photographs. In 1967, two years after closure, the tracks still remained but the site was derelict, the weeds were taking over, and the buildings awaited their uncertain fate.

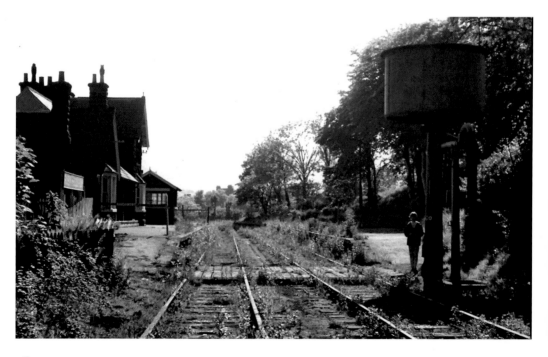

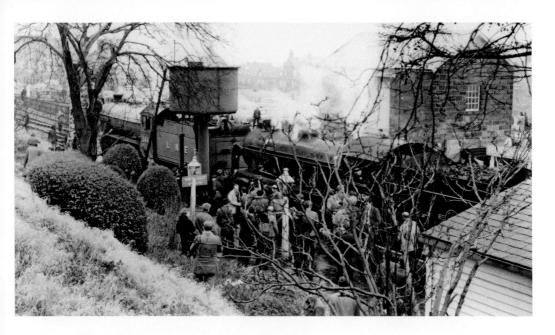

Robin Hood's Bay Station: a source of refreshment

Photographed from the embankment this is another view of the 'Whitby Moors Rail Tour' with the engines taking water at Robin Hood's Bay. The train ran on to Whitby and then down the Whitby—Pickering—Malton line that closed, between Grosmont and Malton, on the same day. Robin Hood's Bay had been a popular destination for the adventurous traveller long before the railway was built, and it featured on the front covers of the official guides published by the S&WR Co in the 1890s.

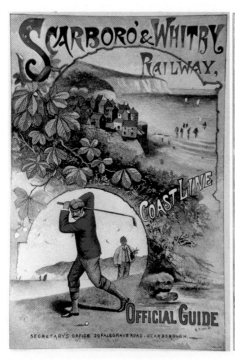

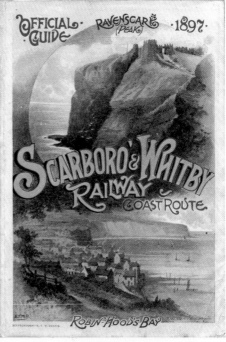

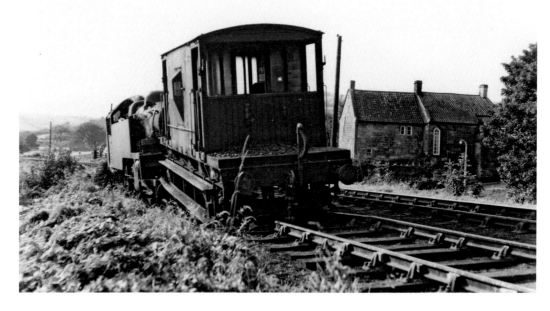

Robin Hood's Bay Station: out of control
Many accidents have been recorded on the S&WR from the very earliest days. Seven men died during construction of the line, between 1872 and 1885, most due to falls of clay in the deep cuttings. Later incidents included making a nuisance with too much smoke and running through signals at danger. The incident photographed here happened when a ballast train ran out of control through the station in October 1961. Six days later it took two steam cranes to lift the engine back on to the track.

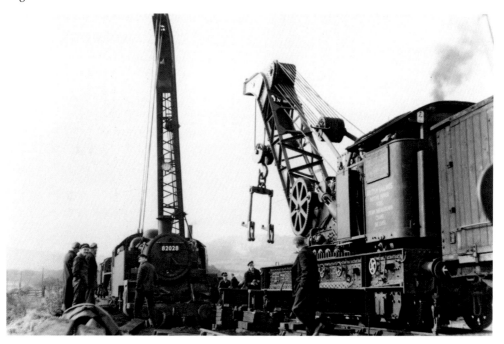

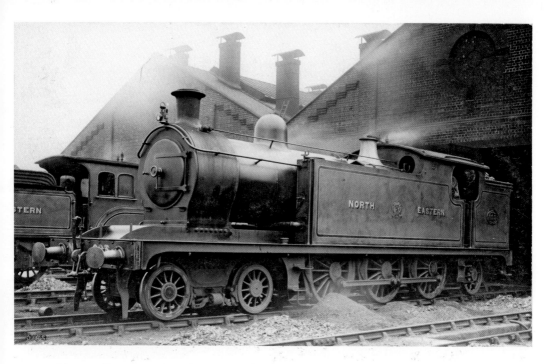

Robin Hood's Bay Station: the power of steam

Motive power on the line in the early days was provided by small tank locomotives but these were found to be inadequate for heavier trains. Class 'W' tank engines were specially designed for the sharp curves and steep gradients of the S&WR. Ten were built and became known as 'Whitby Willies', this one is simmering outside Scarborough engine shed. In 1928 Sentinel steam railcars were introduced to provide a more economical service; this one is pictured at Robin Hood's Bay on a test run in 1927.

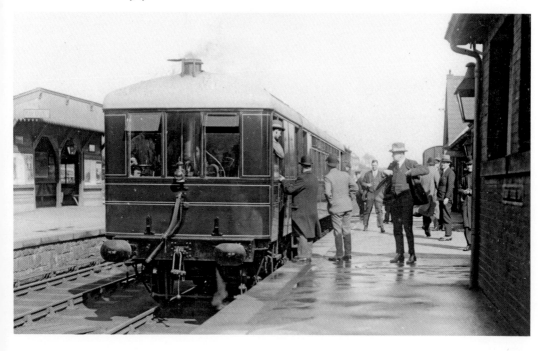

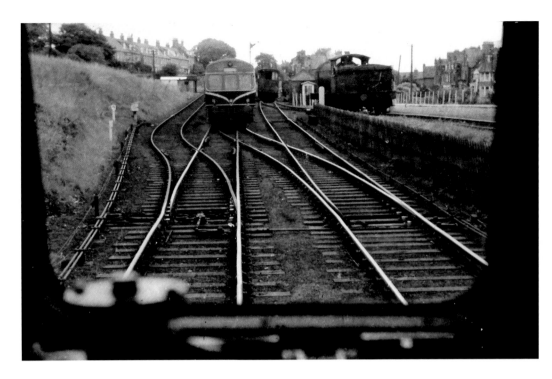

Robin Hood's Bay Station: a DMU confrontation

Two DMUs face each other at Robin Hood's Bay station but are protected from collision by the position of the points. The oncoming DMU, bound for Scarborough, will take the line on the right to the 'up' platform. When it has passed both points will change and the photographers train will proceed to Whitby on the single line. The present-day scene gives no clue as to the former use of what is now the large car park used by most visitors to Robin Hood's Bay.

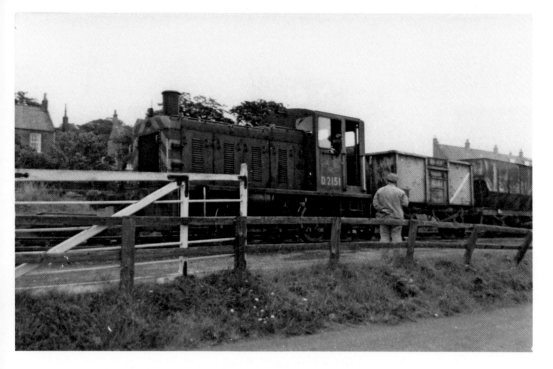

Robin Hood's Bay Station: two last trains and a last ticket

The last goods train brought the final wagons of coal to the station on 4 August 1964 (see also page 74). Coal still continues to be distributed from a site at the south end of the station. The very last train, in the lower photograph, was the contractors special mentioned on page 55. In October 1967 it had screeched up the rusty track, all the way from Scarborough, causing some people to believe that the line was reopening!

Inset: A last ticket – valid for travel after the line closed!

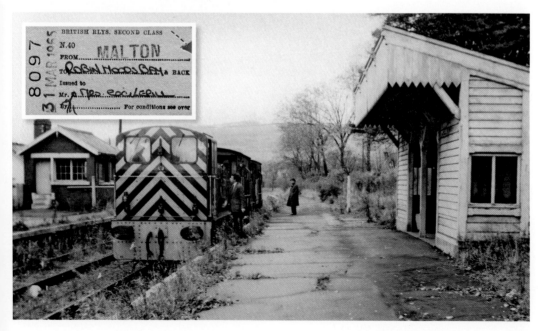

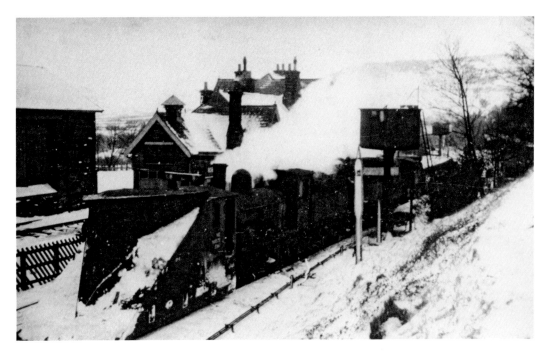

Robin Hood's Bay Station: silhouettes in steam and snow
Snow was often a problem in winter – the deep cuttings and exposed nature of the line along the coast meant that the tracks could soon become blocked by drifting snow (see pages 61 and 70). Snow-plough trains like this, in 1947, could usually clear the line but high winds would often fill in the cuttings again very quickly. Summer visitors, in their cars, little realise how treacherous the local roads can be in winter, despite global warming!

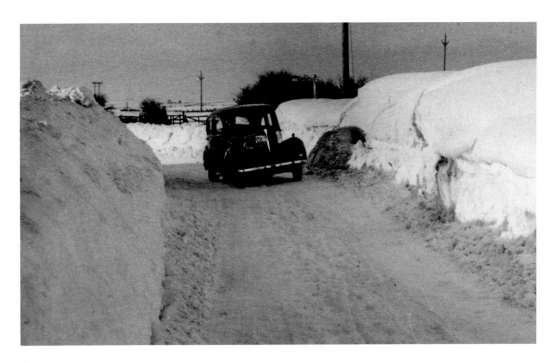

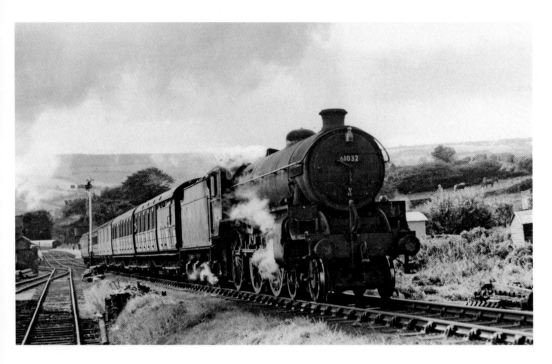

Robin Hood's Bay Station: climbing out of the Bay

The gradient northwards from the station was at 1 in 43 and its steepness is clearly seen in this shot of a five-coach passenger train climbing away from Robin Hood's Bay on its way to Whitby. Five coaches was the maximum load, for one engine on this route, more than five necessitated the use of a second or pilot engine especially if climbing up the steep 1 in 39 gradient to Ravenscar. DMUs, being lighter in construction, rarely had any trouble climbing the gradients on the S&WR.

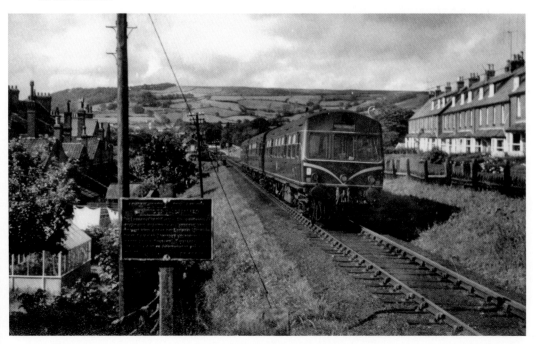

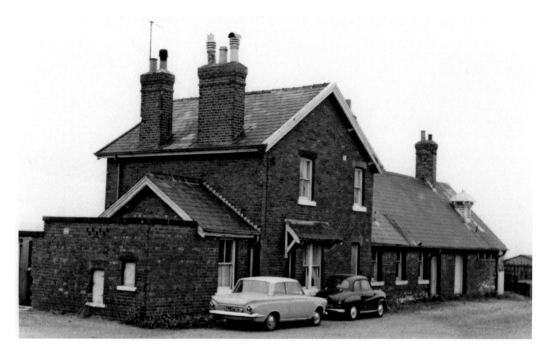

Hawsker Station: a view from the Whitby Road

The design of Hawsker station was very similar to that of Scalby except that it was built of brick as it was closer to Whitby Brickworks whilst Scalby had access to nearby stone quarries. The lower photograph, from the Scarborough—Whitby road (A171), shows the changes that have taken place here. The building now includes a cycle hire business in an ideal position to access the trailway which is now part of the National Cycle Network.

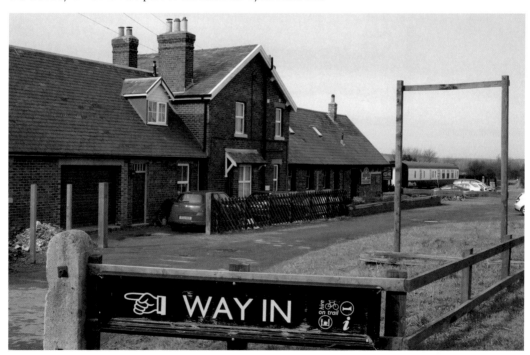

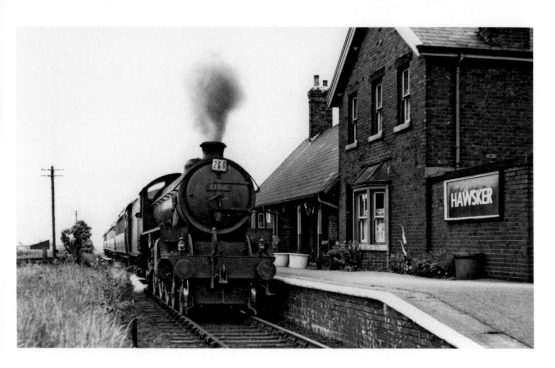

Hawsker Station: from the south

Hawsker station, like Scalby and Fyling Hall stations did not have a passing loop or second platform, but like them, had a small goods yard. The main traffic dealt with here was milk from the local farms. The rail track, between Hawsker and Whitby, remained *in situ* for nine years after the line closed in 1965 as there were plans to site a potash refining centre in the area. The trailway, on the left, runs parallel to the original track-bed.

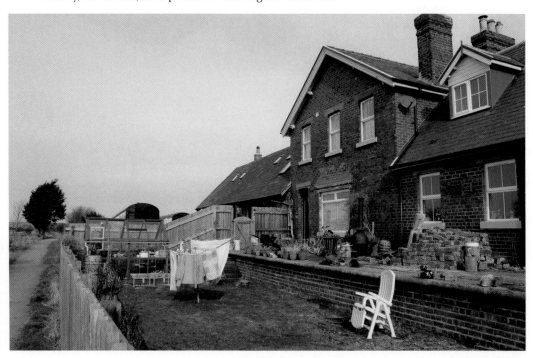

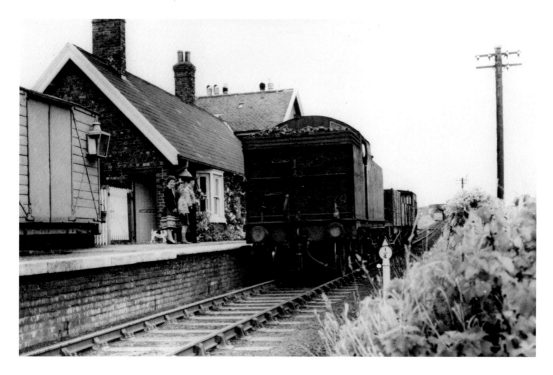

Hawsker Station: from the north

The Scarborough-Whitby goods ambles slowly through the station in 1958. Shunting in the goods yard was done with a wire rope from the locomotive on one line to the wagons on an adjacent line. This was accepted practice but was a procedure that was prone to frequent accidents. Shortly after closure the station was a scene of neglect and weeds were beginning to take over before the station gained a new lease of life. There is now the welcome Trailways Tearoom in the old waiting room.

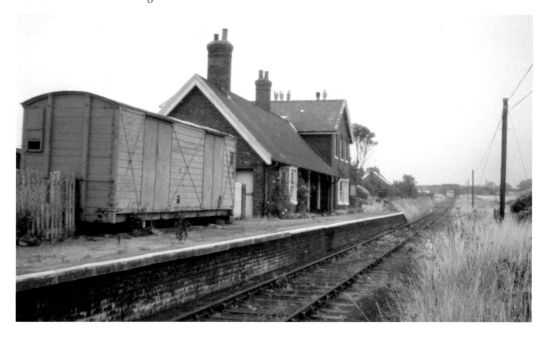

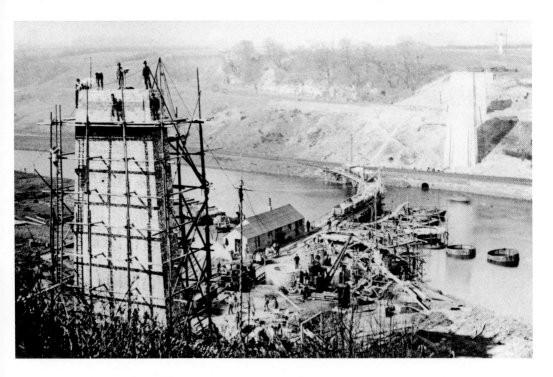

The Esk (Larpool) Viaduct: a monumental project

This is a remarkable pair of views of the Esk Viaduct taken eighty years apart. The first shows the viaduct under construction between October 1882 and October 1884. When completed the 13-arch viaduct was 915 feet long, 125 feet high from the river bed to the parapet and was estimated to contain five million bricks. The second view, taken in 1963, shows a DMU crossing the viaduct as the evening sunshine slants through the arches.

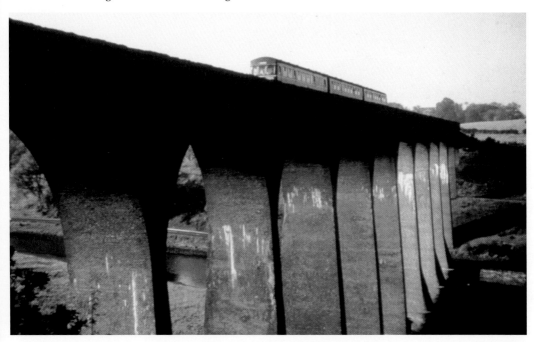

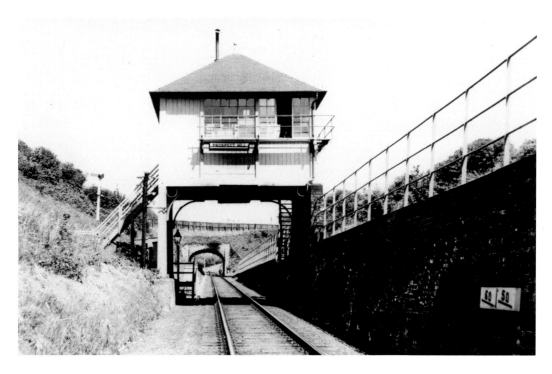

Prospect Hill: an outstanding signal box

The signal box at Prospect Hill was unusual in being built over the track. The line came up from Whitby on a gradient of 1 in 50 and continued under the A171 road bridge to West Cliff station, Redcar and Middlesbrough. In the lower photograph, taken in 1964, the S&WR passes the signal box at a higher level and joins the Whitby – Redcar line just short of the road bridge. Trees now fill this deep cutting but the trailway continues through them and under the road bridge.

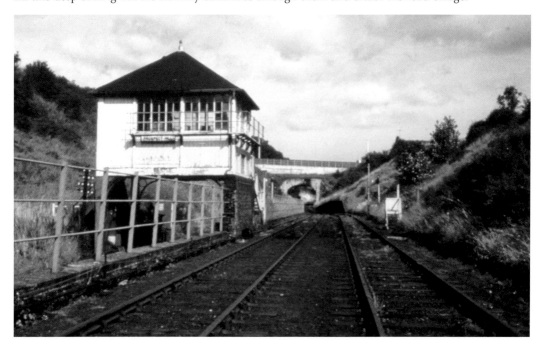

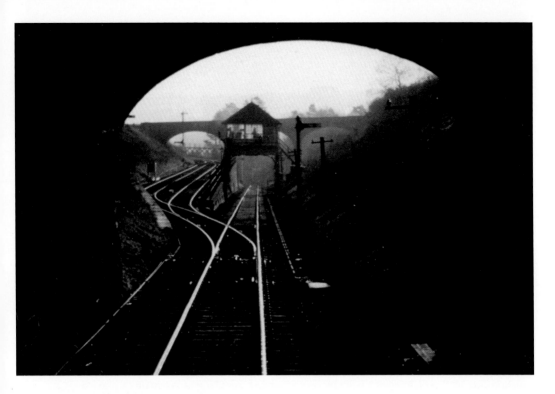

Prospect Hill: taking the tablets

This view, taken in 1965, shows the termination of the S&WR at its junction with the line up from Whitby Town station. This too was a single track line and the tablet and pouch system was used to prevent two trains being on the same section of track (see page 9). In the lower photograph the signalman is exchanging tablets with the driver of the DMU. The pouch being passed to the driver would contain a Prospect Hill—Bog Hall tablet (inset).

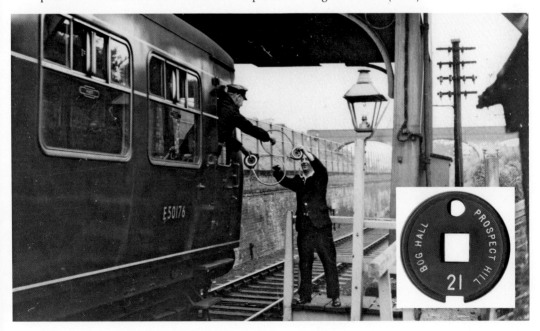

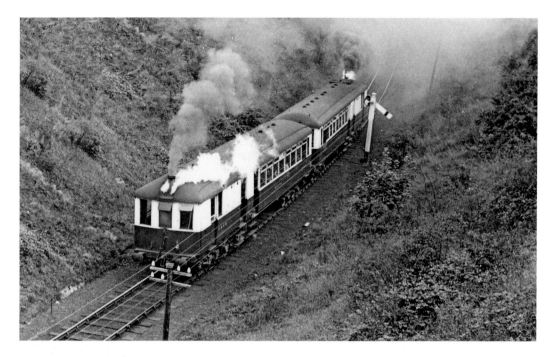

Prospect Hill: the ascent from Bog Hall

Between Bog Hall and Prospect Hill the line ascended steeply at a gradient of 1 in 50. For a number of years a shuttle service was in operation between Whitby Town and Whitby West Cliff stations as trains from Scarborough worked a through service to Saltburn up to 1932, and to Middlesbrough from 1933. The shuttle service was operated by a pair of Sentinel steam railcars for a few years, whilst excursion trains often required the services of a pilot engine from Whitby Town Station to Ravenscar.

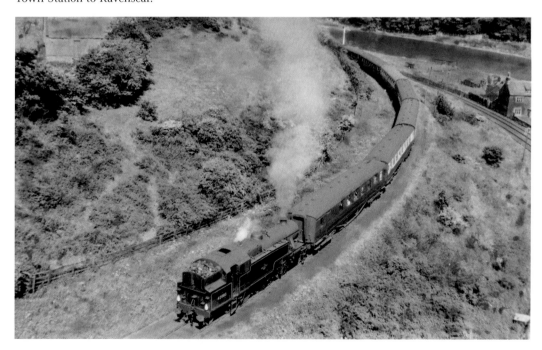

Bog Hall: the approach to Whitby

Two sets of signals frame a view of Whitby and the junction of the former Whitby, Redcar & Middlesbrough Union Railway with the line from Pickering and the Esk Valley. To the right of the tall signal is Whitby's famous and historic landmark – Whitby Abbey. The coastal railway north of West Cliff Station closed in 1958 and the track in the foreground was lifted after the potash scheme fell through (see page 87). The recent view of the line into Whitby was taken from the new road bridge over the river Esk.

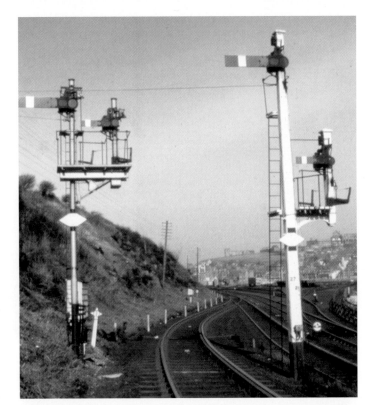

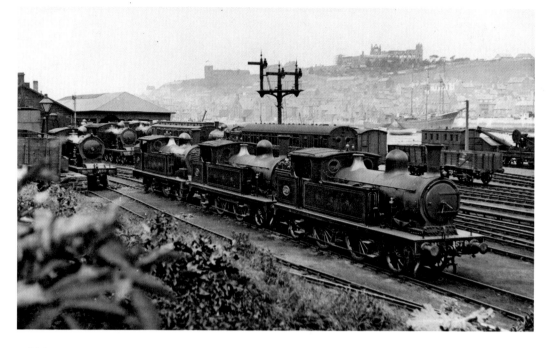

Whitby Town: engine shed and goods yard

The Whitby—Pickering Railway opened throughout in 1836 and was worked by horse-drawn carriages until 1845 when it was connected to Malton on the York—Scarborough line. The Esk Valley line to Battersby and Middlesbrough opened in 1865 and the coast line northwards in 1883. The engine shed, on the left in both photographs, has seen considerable changes in the last few years. Where there once was a busy goods and locomotive yard are now parking spaces for cars, next to the new marina.

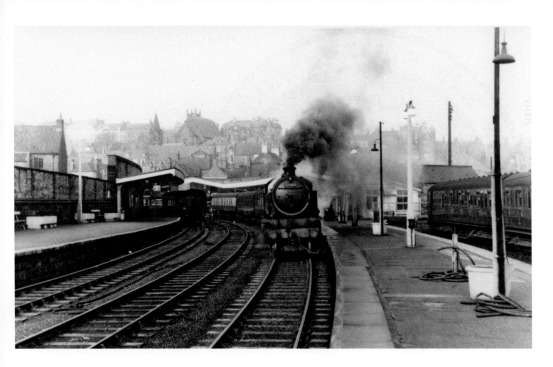

Whitby Town Station: the end of the journey

Whitby Town Station was the end of the journey between the two towns although it often entailed a change of trains at West Cliff Station. Speeds were low because of the steep gradients and sharp curves but this did allow time to take in the magnificent scenery around Robin Hood's Bay and Ravenscar. Today Whitby Town Station is a very attractive place and a delightful one at which to embark on a train journey, either up the picturesque Esk Valley Line or to the North Yorkshire Moors Railway.

Inset: a Whitby Town station enamel totem sign.

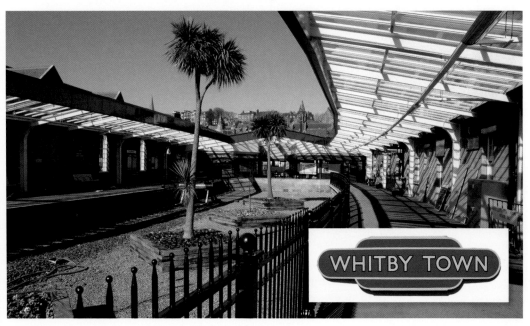

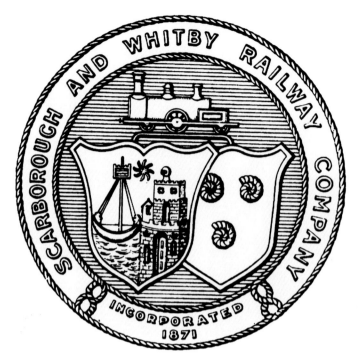

The official seal of the Scarborough & Whitby Railway Company.

Acknowledgements

I would like to thank the following people and organisations for their help and for allowing me to use their photographs: J. W. Armstrong, Dave Bointon, Alan Brown, J. L. Carr, John Childs, G. E. Crabtree, Frank Dean, Colin Foster, W. Leslie Good, Charles Haines, Tom Harland, Alf Hart, Ken Hoole, H. G. W. Household, Alan King, G. C. Lewthwaite, John Mallon, Cecil Ord, Brian Rodda, John Rotherham, T. E. Rounthwaite, Fred Rowntree, Ernie Sanderson, John Scafe, Jim Sedgwick, Norman Skinner, F.M. Sutcliffe, David Turner, Brian Webb, John Williams, Scarborough Evening News and Scarborough Public Library.

I am also grateful for the assistance in various ways of: R. E. Ascough, Eileen Bointon, R.W. Carr, C. A. Goodall, Sue & Steve Hargreaves, A. T. Hart, Laurie Hunter, Sue & Simon Johnson, Rachel Leatham, Beryl McNeil, and all the many people who have provided useful snippets of information, old photographs, memories and stories about the line over the last thirty-five years – I am sorry I could not squeeze it all into this book!